M000273077

HIDDEN HISTORY
of
NEW HAMPSHIRE

HIDDEN HISTORY
of
NEW HAMPSHIRE

D. QUINCY WHITNEY

THE
History
PRESS

Published by The History Press
Charleston, SC 29403
www.historypress.net

Copyright © 2008 by D. Quincy Whitney
All rights reserved

Cover design by Marshall Hudson.

Cover image: "Old Man Framed by Branches," 1985. *Photo Credit: E.W. Whitney III.*

First published 2008
Second printing 2009
Third printing 2010
Fourth printing 2012
Fifth printing 2013

ISBN 978-1-5402-1914-5

Library of Congress Cataloging-in-Publication Data

Whitney, D. Quincy.
Hidden history of New Hampshire / D. Quincy Whitney.
p. cm.
Includes bibliographical references.

1. New Hampshire--History--Anecdotes. 2. New Hampshire--Biography--Anecdotes.
I. Title.
F34.6.W48 2008
974.2--dc22
2008022545

Notice: The information in this book is true and complete to the best of our
knowledge. It is offered without guarantee on the part of the author or The History
Press. The author and The History Press disclaim all liability in connection with the
use of this book.
All rights reserved. No part of this book may be reproduced or transmitted in any form
whatsoever without prior written permission from the publisher except in the case of
brief quotations embodied in critical articles and reviews.

Hidden New Hampshire History—

Hidden not from view,
but from the common view of many,
like the Old Man—visible only from the right angle,
otherwise, a jumble of rocks, even now
forever gone from view—
except in the truth of the imagination.

For Dad, who carries stories in his bones;
For Eli, who carves stories of his own;
For Gabriel and Meranne—wherever they roam,
They all call New Hampshire Home.

CONTENTS

CONTENTS

PREFACE

In 1998, it was determined that New Hampshire would be the featured state on the Mall in Washington, D.C., at the Smithsonian Institution's Annual Folklife Festival, held from June 23 to July 4, 1999. In preparation for this celebration in the nation's capital, the New Hampshire State Council on the Arts joined with many other state organizations to research history and build sets that would showcase the Granite State.

One unique research subject that was uncovered centered on the fact that New Hampshire had inspired many of its residents to initiate impressive feats of personal and professional magnitude that had had an integral role in shaping state history. Initially referred to as "New Hampshire Firsts and Bests," this research topic encompassed many idiosyncratic, often unsung moments in New Hampshire history—and resulted in an anthology of local history events, many of which were largely unknown not only to the public but also to Granite State residents.

Because of my extensive coverage of New Hampshire cultural history as the primary *Boston Globe New Hampshire Weekly* arts feature writer for fourteen years, I was asked by the New Hampshire State Council on the Arts to research this topic. The resultant research report included sixty-two little-known moments in New Hampshire history.

Hidden History of New Hampshire is an anthology composed of a selected portion of these incidents with several new stories added. As anyone can tell by perusing the table of contents, this book offers an impressive collection of intriguing local history stories about New Hampshire.

ACKNOWLEDGEMENTS

First and foremost, I want to thank my husband Eli for the many hats he wore to help me with this book—agent, photographer, stenographer, graphics specialist and number one fan—and for his unswerving support in every other aspect of my life.

Next, I have to thank Judy Northup for asking me to write features for the *League of New Hampshire Craftsmen Newsletter*, where I became impassioned about the cultural news of the Granite State.

A multitude of thanks must go to *Boston Globe New Hampshire Weekly* editor John Burke, who took a chance on me in 1987, and to Janet Insolia, my subsequent editor at *NH Weekly*, who never lost her sense of humor. Both editors fostered an atmosphere at *NH Weekly* that nurtured and challenged each writer to stretch and excel.

Many thanks to Van McLeod, commissioner, New Hampshire Department of Cultural Resources, for his untiring enthusiasm for the cultural life of the state and for his support of and interest in my particular path.

Throughout my stint as a *Globe* feature writer, I worked on many stories linked to the wonderful people who make up the New Hampshire State Council on the Arts. I want to thank Director Rebecca L. Lawrence, Arts in Education Coordinator Catherine O'Brian, Traditional Arts Coordinator Lynn J.M. Graton, Creative Communities Coordinator Judy Rigmont and Visual Arts Associate Julie Mento. I especially want to thank the Arts Council for asking me to research "New Hampshire Firsts" for the 1999 Smithsonian Folklife Festival.

The production of any book with lots of wonderful images usually signifies the cooperation and generosity of many people. I am most grateful to everyone who took an interest in this anthology.

At the League of New Hampshire Craftsmen Headquarters, I want to thank Executive Director Susie Lowe-Stockwell and assistant Shelly Roy. I

also want to thank Carol Fusaro, Sullivan Creative, a public relations and marketing firm located in Newton, Massachusetts.

Many thanks to Joan Desmarais, assistant director of the New Hampshire Historical Society, and librarian Bill Copeley.

My thanks to Steve Barba, former managing director at The Balsams and Plymouth State College executive director of university relations, for his willingness to paint a small portrait of only one aspect of his long association with this grand hotel, and The Balsams Reservations and Front Desk Manager Jerry Owen for showing me the Ballot Room.

At the Lake Winnipesaukee Historical Society, I thank Ann W. Sprague for her interest and enthusiasm.

At the Northern Forest Heritage Park, I thank Jim Wagner, AV Economic development director, and Berlin photographer Mark R. Ducharme.

Many of the unique images in this book illustrating tales of the White Mountains would be missing without the interest and gracious support of three people. At the Mount Washington Observatory Library, I owe many thanks to Peter Crane for his willingness to do thorough and extensive pictorial research. At the Mount Washington Auto Road Visitor Center, I thank Manager Howie Wemyss for his enthusiasm and his stories. At the New England Ski Museum, special thanks to Director Jeff Leich, who not only helped with images but also helped organize my thoughts about New Hampshire's complicated ski history.

At the Mount Washington Hotel, I also want to thank Adventure Desk Manager Eileen Savoy for a tour of the hotel and Public Relations Manager Irene Donnell for her support and astute photographic research.

At the Appalachian Mountain Club Headquarters in Boston, I want to thank Senior Public Relations Manager Laura Hurley and AMC librarian Becky Fullerton, and Rob Burbank, AMC manager at Pinkham Notch.

At the MacDowell Colony, I thank Communications Director Brendan Tapley.

At Enfield Shaker Village, I thank Executive Director Mary Boswell.

At the Plainfield Historical Society, I thank archivist Nancy Norwalk and Margaret Drye, president of the Meriden Bird Club.

In Littleton, I thank Violet Hopkins, archivist at the Littleton Historical Society; author Linda McShane; and Jean Dickerman, director of the Littleton Public Library.

Many thanks go to Andrea Thorpe at the Richards Free Library, Newport.

At the Rye Historical Society, thanks to Leigh deRochemont and Tony Goodwin. At the Swenson Granite Company, many thanks to Kevin Swenson.

At the Mary Baker Eddy Library in Boston, I thank Curator Alan Lester and Copyright Administrator Sally Ulrich.

At the Christa McAuliffe Planetarium, I thank Executive Director Jeanne Gerulskis, Development Director Kathleen Regan, Director of Special Events and Visitor Services Gina Bowler, Astronomer Kate Michener and Producer Sandt Michener.

Thanks to Bob Shea, artistic director of the Dana Center at Saint Anselm's College, Manchester, and also artistic director of the Barnstormers, and his assistant, graphic artist Janina Lamb, Lamb & Lion Studio, Tamworth.

At the Hawke Meetinghouse, thanks to Chris Stafford, who kindly allowed me to view the interior of the Hawke Meeting House, and Bill Gard, Hawke Meeting House Committee chairman, who clarified some history.

At Wentworth-By-The-Sea, special thanks to General Manager Frank Wettenkamp and Stephanie Seacord, public relations for the Portsmouth Peace Treaty Forum and the New Hampshire Division of Travel and Tourism Development.

On the Isles of Shoals, I thank Joe Watts, Vaughan Cottage Museum Manager.

At Dartmouth College, I thank Sarah Hartwell at the Rauner Library and the Dartmouth College Archives at Baker Library; Dartmouth Grounds Supervisor Bob Thebodo; and the Dartmouth Medical School.

At Strawbery Banke, I thank Director of Development Joanna Brody.

At the Augustus Saint-Gaudens National Historic Site, I thank Superintendent B.J. Dunn and Curator of Chief Cultural Resources Henry Duffy.

At the Brookline Historical Society, thanks to Peter Webb.

At the North Conway Public Library, thanks to Andrea Masters.

At the Wolfeboro Historical Society, special thanks to President Jim Rogers.

At the Milne Special Collections Library, the University of New Hampshire, I thank Photographic Services Specialist Lisa Nugent, librarian Nancy Mason and the Lotte Jacobi Collection.

I thank former *Nashua Telegraph* sports editor Steve Daly.

At the Cathedral of the Pines, special thanks to Patrice A. Petry, Gretchen Ziegler for her tour, and Edward Brummer Jr. for sharing stories about his family legacy.

At the New Hampshire State House, thanks to Walter Sword, Protective Services and New Hampshire State House doorkeeper, for his humor and hospitality.

Finally, I want to thank Don Murray, who once called me a mentor when, in fact, the reverse is true many times over.

INTRODUCTION

Fog and storm come often, but the clearing brings ample reward. Cloudless days with views of indescribable vastness; glories of sunrise and sunset; mysterious cloud effects; a day of sunshine overhead and a sea of cloud below; evenings of full moon, its rays mirrored in the ocean and in the distant lakes…frost storms now and then, even in summer, coating rocks and woodwork and telephone lines with feathery white spangles; fierce gales before which staunch buildings tremble but never lost their grip on their rocky anchorage—all and more are among the experiences of life at that lofty outpost.

So wrote Frank Burt, son of White Mountain photographer and newspaper editor Henry Burt, about weather atop Mount Washington. In many ways, the extreme changeability of weather atop the summit reflects the Granite State as a whole, the smallest New England state that has four types of topography to match its four seasons. New Hampshire is the state where within a three-hour drive, one can see rolling farmland, mountains, rivers, lakes and ocean, and on many a day experience four distinct seasons in the journey from dawn to dusk.

That incredible topographic and seasonal variety has challenged the people of New Hampshire to be deliberate in their choices of place, and when passion for place grows, to develop the ingenuity, flexibility and diligence to make do in order to stay put. Throughout history, the land and seasons of the Granite State have challenged its people to be creative with and protective of the environment, inspiring them to build something directly out of the land like a ski hill or a mountain path, or to react to the needs of the local community.

The love of the land and its seasons spurred New Hampshirites to form the first mountaintop newspaper and found the first forest protection society in the nation. The mountains and lakes inspired Granite State residents to

build summer resorts and winter retreats, to found a pioneering ski club and the largest icehouse in the world, to invest in a mountain-climbing train when many thought it impossible, to build an aerial tramway to see and ski the mountains and to market images of grand vistas through the largest stereoscopic view company in the world.

The rivers and the seacoast inspired the first government shipyard in the nation and the development of numerous "firsts" in marine and submarine technology, including the development of the distinctive Piscataqua River Gundalow. The eighteen miles of New Hampshire coastline welcomed the first transatlantic cable in the country and hosted the largest sailing regatta in the nation. Inland waterpower built the largest textile mills in the world.

Love of travel to view the distinct vistas of the state made the innovative Concord Coach the stagecoach of the nation. Among its many covered bridges, New Hampshire boasts both the oldest and longest in the nation. Love of nature spurred one resident to create a wild game preserve, another to found the nation's first bird club and three generations of one family to climb "Old Stone Face" annually in order to pin and glue together that rock profile that has come to symbolize the Granite State, the same profile that eventually lost its battle with nature and leaves its own mythological legacy.

Diligence with natural materials combined with entrepreneurial spirit spurred people to create cottage craft industries and eventually the League of New Hampshire Craftsmen, which today still hosts the oldest crafts fair in the nation. Three hundred men labored for six years to quarry, split and finish 350,000 cubic feet of New Hampshire granite to build the Library of Congress, the largest building in the world when it was completed in 1897.

The resourcefulness of Granite Staters in their efforts to innovate and improvise is the reason for this incredible and intriguing cast of true stories about New Hampshire people living what they love and loving what they do.

HOME, TOWN, COMMUNITY

EARLIEST NEW HAMPSHIRE NEIGHBORHOOD

History, like memory, is a chaotic thing. Time meanders like a river and shapes and reshapes the spaces we carve out to live our lives. Historic preservation can be equally chaotic as it attempts to freeze time and space. Nowhere is the menagerie of time and space more apparent than in the earliest neighborhood in the state, a gathering of forty-two buildings just off the banks of the Piscataqua River in downtown Portsmouth. The neighborhood is Strawbery Banke, named after the wild berries Captain Walter Neal saw growing on the west bank just two miles from the mouth of the Piscataqua River in 1630.

This first neighborhood began in the 1630s, for economic rather than religious reasons, with the building of a communal structure, the Great House—a combination storehouse, trading post and living quarters. Henry Sherburne, a farmer and tavern keeper, came to Portsmouth in the 1630s. A decade later, brothers John and Richard Cutt, emigrants from Bristol, England, developed a fishing trade on the Isles of Shoals, acquired land and moved to Portsmouth to set up a sawmill. Through the timber trade, John Cutt became one of the wealthiest men in New Hampshire. When the Cutt brothers died in the 1680s, their wills provided that their land be divided into urban house lots, creating the second neighborhood on the banks of the Piscataqua. By 1700, all of Strawbery Banke had been settled and the urban process in Portsmouth had begun.

How many other neighborhoods have been built upon the foundations of these first two? The same land that had once been a tidal inlet where the sea rose and fell fourteen feet a day became a many-layered neighborhood where archaeological evidence reveals traces of each preceding generation.

By 1695, John Sherburne, son of Henry—a mariner instead of a farmer—had purchased a parcel of land near the cove and the Great House. Today the Sherburne House, the dark brown, double-gabled house near the road to downtown Portsmouth, built in 1695, is the earliest building in Strawbery Banke. From that beginning point chronologically, the paths at Strawbery Banke meander across time and space, across historically preserved buildings where visitors can wander, adjacent to other buildings not open to the public except to display their historic architectural features.

But throughout its history, this same "Puddle Dock" neighborhood has—in all its varied forms—always been a mixing pot of social classes, a neighborhood where a ship's carpenter and stagecoach driver lived next to a lawyer and a governor, a neighborhood of laborers, artisans, fishermen and sea captains, traders and merchants.

Strawbery Banke is a living museum in more ways than one—a conglomeration of different periods of four hundred years of New Hampshire seacoast history. But it is also perhaps a "modern" museum, a patchwork quilt of eras and styles, a reflection and record of constant urban renewal, the ebb and flow of one community continually reinventing itself in the context of historic buildings relocated to protect them from demolition.

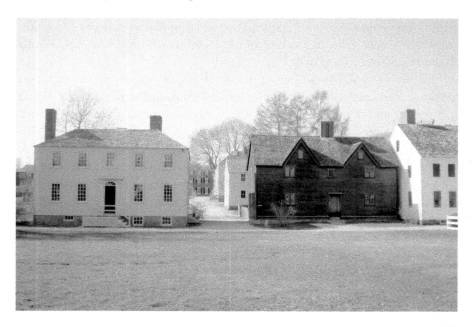

Strawbery Banke. On the left is the Lowd House, circa 1810. The dark house is the Sherburne House, built in 1695. *Photo Credit: E.W. Whitney III.*

Rather than being a crystallized record of social and cultural history frozen in one particular era, Strawbery Banke is fluid history at its best, history in which each layer of a generation influences and shapes the next in unanticipated ways. In its chronological messiness, Strawbery Banke perhaps best illustrates the nature of urban renewal and preservation, a process that is neither linear nor simple.[1]

Oldest Unrestored Congregational Meetinghouse

The Hawke Meeting House in Danville is thought to be the oldest un-restored and unaltered meetinghouse in the Granite State. In colonial times, the word *meetinghouse* indicated that the building was used for both religious and secular purposes.

Erected prior to June 12, 1755, by twenty-seven local proprietors who in 1760 conveyed it to the newly incorporated Parish of Hawke—now the town of Danville—the Hawke Meeting House held its first town meeting on March 10, 1760. The Olde Meeting House was used for religious services until 1832, when a Free Will Baptist church was established to house religious gatherings. In 1886, the Hawke Meeting House held its last town meeting, replaced by the newly built town hall. For many years, the Olde Meeting House was no longer used. The unadorned exterior of the Olde Meeting House belies the craftsmanship within where hand-hewn timber, fluted pilasters and paneled walls set off what is believed to be the oldest remaining example of a high pulpit in New Hampshire.

One of the most distinctive aspects of the interior of the Hawke Meeting House are the forty-three pew boxes—twenty-eight partitioned stalls that fill the floor space downstairs and fifteen set around the perimeter of the upstairs gallery reached by two winding staircases on either end of the building. Records show that the boxes were auctioned to families to fund the building of the meetinghouse. The larger stalls and those closer to the front were sold at higher bids so, in this sense, a family's economic status in Hawke was easily discerned by the position and size of the pew box that bore a family's name. The less expensive boxes housed in the upstairs gallery stand adjacent to two long pews on opposite walls that are thought to have been designated for either indentured servants or blacks. The original pump organ sits in the center of the gallery.

At some point, residents removed the stalls and stored them upstairs in the gallery—word has it—supposedly to make room for dances. But

Puritan conservatism prevailed and no dances were held there. In 1909, the Old Meeting House Association was founded to maintain and preserve the old building and to use it once or twice a year. In 1937, Lester Colby funded the repair and replacement of the stalls in memory of his mother, Lucy Spofford Colby. New brass plaques on each stall carry the original family names that appeared on each properly designated stall, according to historical town records. "It must be remembered that these stalls were considered property, territory, thus the perimeter marking each space. People would pass along their pew to the next generation," explained Bill Gard of the Danville Historical Society.

Reverend John Page, a Harvard man with a family of nine children, was the only permanent minister to serve the meetinghouse. In the 1782 smallpox epidemic, two families of Tuckers—living in an area called "Tuckertown," the road to which lies opposite the meetinghouse—contracted smallpox. Though the Tuckers had no food or firewood, townspeople fearful of contracting the disease would not visit them—except for Reverend Page who died while tending to the Tuckers.

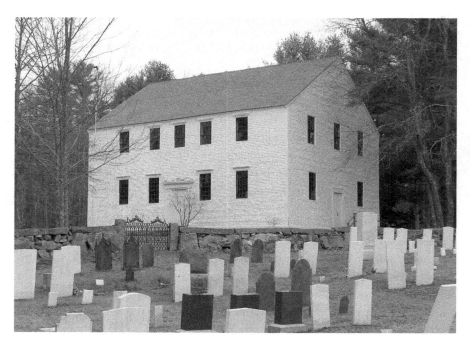

The Hawke Meeting House, 1755. *Photo Credit: E.W. Whitney III.*

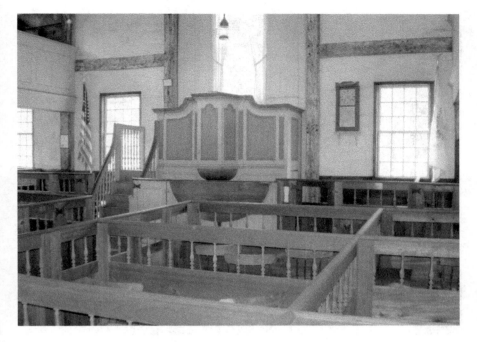

The interior of the Hawke Meeting House, featuring one of the earliest raised pulpits.
Photo Credit: E.W. Whitney III.

The Hawke Meeting House is open to the public two times a year—
Memorial Day and for a nondenominational service on Old Home Day, the
fourth Sunday in August.[2]

OLDEST FIRST-GENERATION SHAKER MEETINGHOUSE

The Shaker Village at Canterbury was "called to order" in 1792 when a
group of Shakers, followers of founder Mother Ann Lee, gathered to form
their seventh community and build a meetinghouse on the one-hundred-
acre farm of Benjamin Whitcher, who became a Shaker and gave the
farm to the community. Shaker diaries record that the meetinghouse—the
first and most important building to initiate and gather the community
together—was framed with great reverence, in one day and in silence.

Seldom has inner conviction found so clear and consistent an outward
expression as in the case of the Shakers. Their carefully manicured fields
not only fostered the ingredients for food and medicine but also were

The meetinghouse at Canterbury Shaker Village was built in 1792. *Photo Credit: D. Quincy Whitney.*

manifestations of a mindset about the earth and how to use and nurture it. The simplicity and grace of a Shaker chair expressed more than the materials gathered to make it. There was a spirituality about the way the Shakers set a room—not just a sense of design, but an attitude inspired by belief in a higher harmony.

The meetinghouse at Canterbury perfectly expresses the inward convictions of a spiritual community that believed equally in celibacy and community. This seemingly paradoxical juxtaposition expresses itself exquisitely in the design of the meetinghouse with its two identical, separate but equal front doors—one for women and one for men. At its peak in the 1850s, more than three hundred Canterbury Shakers lived and worked in one hundred buildings on 3,000 acres. Today, twenty-one buildings remain surrounded by 690 acres of fields and woodlands. Canterbury Shaker Village has operated as a museum since 1992, when the last Shaker sister in residence, Ethel Hudson, died.[3]

First Free Library and
First Publicly Funded Library

The Dublin Social Library was founded on October 29, 1793. Isaac Appleton was selected as clerk while Moses Greenwood became the first librarian. The first purchase of books was recorded as $56.60. The price of a library share was $2.00. Subsequent librarians were Eli Adams, Dr. Samuel Hamilton, Moses Marshall, Cyrus Chamberlaine, Joseph Appleton and Aaron Appleton. In 1805, the library voted to allow $2.00 to Aaron Appleton for "keeping the library."

The library was incorporated in 1797. By 1798, the book collection had risen to ninety-three, and records state that Moses Greenwood paid $11.25 to Matthew Aikin for covering the books with sheepskin. Today some of those books still have the same sheepskin covers. Reading privileges were granted to Reverends Edward Sprague and Elijah Willard. The Ladies Library of Dublin was founded in 1799.

The State Literary Fund was founded in 1821 to be used to create a state university, an idea that never materialized. The legislature dispersed the funds to different towns with authorization to support "common free schools or other purposes of education." The Dublin Juvenile Library was founded in 1822 with the stipulation that the books were "Free to All Persons in the Town." Since it was free to all Dublin citizens, this library, which by 1852 had grown to include over nineteen hundred volumes, was not only a "free" library but a "public" library as well.

The Peterborough Town Library was the first library supported by public taxation, largely inspired by the literary interests of a new minister, Abiel Abbot. In 1828, Abbot recommended a juvenile library be located in his home, with its two hundred volumes being loaned from its shelves.

In January 1833, Abbot incorporated the Peterborough Library Company, with two-dollar shares and yearly dues of fifty cents, with life membership at six dollars. On April 9, 1833, the proposal came forth in Peterborough that a part of the State Literary Fund be used to purchase books for a town library. The Peterborough Town Library decided to use those funds for the library, making it the first free public library supported by taxation.

The law of 1849 authorizing towns to levy taxes to support libraries perpetuated the trend toward the establishment of free libraries in New Hampshire. In 1891, a library commission was appointed to establish free libraries using state aid. The library movement in New Hampshire became

so pervasive that by 1934, only twelve towns in the state were without libraries and these were served by circulating libraries.[4]

LARGEST TEXTILE MILLS UNDER ONE ROOF

In 1803, Benjamin Prichard of Goffstown built the first cotton mill in New Hampshire at New Ipswich. In 1809, Prichard built the Amoskeag Cotton and Wool Factory on the Merrimac River. In 1815, the mill, while producing little, remained on valuable land, and was acquired by a group of Boston investors. In 1835, that group acquired the Bow Canal Company, the Isle of Hooksett Canal Company, the Amoskeag Locks and Canal Company and, in 1836, Concord Manufacturing Company, to found the Amoskeag Manufacturing Company.

Through these acquisitions, which by their very size today would be subject to antitrust legislation, the Amoskeag Company obtained an unprecedented full title to all water power along the Merrimac River from Manchester to Concord and all the Manchester riverside land that could be used for mill sites.

At its peak in the early twentieth century, Amoskeag Mills was the largest textile mill in the world located in a single community. The mills employed seventeen thousand workers at the time. The Amoskeag Mill complex included thirty major mills, which, in combination with other related buildings, spanned eight million square feet, a floor space approximately similar to that of the World Trade Center in New York City.

The Amoskeag Mills incorporated seventy-four separate cloth-making facilities; three dyehouses; twenty-four mechanical and electrical departments, three major steam-powered plants; and one hydroelectric power station. For one period of time, the Amoskeag Manufacturing Company also produced locomotives and Civil War rifles in addition to textile machinery.

Remarkably, the self-sufficient Amoskeag Manufacturing Company even designed and built its own mill buildings, which in the mill yard's heyday formed an architectural legacy of archways, bridges and iron gates that some have said resembled a walled, medieval city, with lots of care taken even to the matching of bricks when new buildings were built.[5]

New Hampshire's best example of a nineteenth-century textile mill unchanged since the early 1800s is the Belknap Mill in Laconia, considered the oldest unaltered textile mill in the country. Built in 1823 along the banks

of the Winnipesaukee River, the Belknap Mill was an industrial knitting mill that is now a museum. At its peak in 1918, the Winnipesaukee River valley was the knitting and hosiery capital of the world.[6]

Another architectural remnant of the textile mill legacy of the Granite State is the entire town of Harrisville, located in the Monadnock region of southern New Hampshire, where a cluster of red brick mill buildings appear virtually the same as they did 150 years ago—so much so that the entire town, surrounded by nine bodies of water including the Harrisville Pond and Canal, is a National Historic Landmark.[7]

FIRST WOMEN'S STRIKE

On the morning of December 30, 1828, the *Dover Enquirer* reported,

> *TURN OUT—A general turn out of the girls employed in the cotton factories in this town to the number of 6 or 800 took place on Friday last, on account of some imaginary grievance. It has, we believe, turned out to their cost, as well as disgrace....The girls, on leaving the factory yard formed a procession of nearly half a mile in length, and marched through the town, with martial music; accompanied with roar of artillery. The whole presented one of the most disgusting scenes ever witnessed.*

The unsympathetic press was as distant from the world of nineteenth-century mill girls as the girls were from their own roots on the farm. In *The Age of Homespun*, Laurel Ulrich wrote,

> *The first women to enter New England's textile mills thought of their work in much the same way as their counterparts who remained at home, but they soon learned that factory owners and machines were neither as flexible nor as forgiving as the housewives who had once managed their labor. Mechanized production exposed workers to the unfamiliar disciplines of clocks and bells, forcing them to adapt the motions of hands and eyes to the rhythms of machines.*

Factories had integrated all the processes of cloth making under one roof, creating cities that many thought of as exemplary. According to Ulrich, "By

1836, there were eighteen thousand inhabitants in what many considered a model city. The six thousand women in the city's cotton mills outnumbered male employees six to one."

Though the monstrous Amoskeag Mills in Manchester had been the most visible of textile manufacturing centers, Cocheo Mills of Dover, a cluster of brick buildings devoted to the manufacture of printed calico cloth, entered the limelight when their mill girls walked off the job on December 23, 1828.

The *Mechanics Free Press* lamented the fact that though "half the newspapers from Maine to Georgia" had noticed the strike, none had investigated or explained the reasons for the strike—a "set of odious restrictions that not only demanded punctuality but promised to close the gate five minutes after the tolling of the bell and to fine workers each time it had to be opened. 'What would the good people of this city say, to see 3 or 400 girls running, like hunted deer, on the ringing of a bell? They might as well shut up the girls in a nunnery. Furthermore, a regulation forbidding talking while at work reduced the women 'to the level of the State prisoners at Sing Sing.'"

The Dover strike was the first in the nation executed entirely by women; their actions inspired a wave of similar activity over the next decade. In 1829, female weavers did their best to appear respectable as they walked off the job at the Hopewell Mill in Taunton, Massachusetts, donning black silk dresses, red shawls and matching green bonnets. In 1834, when eight hundred workers paraded the streets in Lowell to protest a 25-percent wage reduction, newspapers were again less than sympathetic. The *Boston Evening Transcript* described the actions as "not altogether to the credit of Yankee Girls." A century hence, on February 13, 1922, fifteen thousand employees of the Amoskeag Mills joined nearly fifteen thousand textile workers in other New Hampshire towns to strike cuts in wages. Nearly half of these workers were women. The strike ended in November and won a restoration of pre-February wages.[8]

PIONEER WOMAN EDITOR: SARAH JOSEPHA HALE

Sarah Josepha Hale of Newport, New Hampshire, was arguably the most influential woman in the nineteenth century. As editor of the Boston-based *Ladies' Magazine* from 1828 to 1836, and then first editor of the widely popular *Godey's Lady's Book* of Philadelphia from 1837 to 1877, Hale created an entire cultural consciousness about the status of women

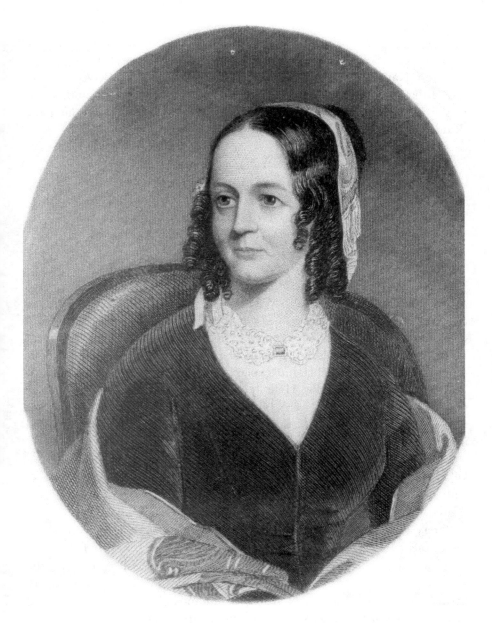

Sarah Josepha Hale (1788–1879), the most important editor of her time. *Courtesy Richards Free Library, Newport.*

and the development of American literature through her magazine. Hale reviewed thousands of books, wrote monthly editorials and published the works of Nathaniel Hawthorne, Edgar Allan Poe, Harriet Beecher Stowe and Lydia Sigourney, in addition to contributing her own fiction and poetry to the magazine. In her book *Our Sister Editors*, Patricia Okker relates the distinguished contributions of Hale:

> *Unlike many of her contemporaries, who used similar ideas to restrict women to domestic roles, Hale insisted on the power of women within both the public and private spheres. Throughout her fifty-year editing career, Hale helped popularize new ideas about reading and genre, and she made significant contributions to the development of professional authorship.*

In addition to her work as editor, Hale also wrote seven volumes of poetry, six volumes of fiction, several popular books on cooking and housekeeping and a nine-hundred-page book about women in history. She edited two dozen books. One of the earliest public supporters of equal rights for women, Hale personified her cause in her own life as she subsequently pursued four different careers—as teacher, innkeeper, business entrepreneur and editor.

In 1806, at age eighteen, Hale opened a school for boys *and* girls. The text for Hale's famous children's tale *Mary Had a Little Lamb* came from her days as a teacher. In 1810, Hale stopped teaching to help her family run an inn, the Rising Sun.

Despite the early loss of her mother and sister to illnesses that almost killed Hale, and the short-lived marriage of nine years that left her a widow with five children under the age of six, Hale, at the age of thirty-three, started her third career. She and her sister-in-law Hannah Hale started a millinery business. Hale continued to write, and got several poems published in various periodicals. In 1825, Hale wrote *Northwood*, one of the earliest novels dealing with the issue of American slavery. Published in 1827, the novel received praise from William Cullen Bryant. One historian, Ernest L. Scott Jr., claimed that the book featured "the most detailed and entrancing picture of a Puritan Thanksgiving in all of American literature." In fact, Hale became a passionate proponent of a national Thanksgiving.

In 1827, Episcopal clergyman The Reverend John Blake asked Hale to come to Boston to edit a ladies' magazine that would be created for her. In March 1828, at age forty, Hale embarked on her last career as magazine editor. In 1837, Hale became the first editor of the widely popular *Godey's*

Lady's Book of Philadelphia, where she remained for forty years. Just prior to the Civil War, *Godey's Lady's Book*, the *Vogue* of its day, was the most widely read periodical in the United States, with a circulation of 150,000. Though Sarah Josepha Hale became the most powerful editor of her time for more than half a century, she may be best remembered for saving Thanksgiving.

Despite the fact that President George Washington made the first Thanksgiving Day proclamation in 1789, setting aside the first Thursday in November as a day for prayer and giving thanks, no regular Thanksgiving Day was observed for the next seventy-four years. Throughout the country, states celebrated Thanksgiving on various autumn days. Hale actively campaigned for thirty-six years for the establishment of a national Thanksgiving Day. In response to receipt of Hale's letters of appeal in 1863 and again in 1864, President Lincoln proclaimed a national Thanksgiving Day for both those years, in hopes that such a proclamation would mend differences between the states, and affirm constitutional order and national unity during the Civil War. Later presidents proclaimed the last Thursday in November as a national Day of Thanks, with the exception of President Franklin D. Roosevelt, who in 1939 set the holiday one week earlier. In 1941, Congress ruled that the legal and federal Thanksgiving Day holiday would be the fourth Thursday in November.[9]

VISIONARY RELIGIOUS LEADER: MARY BAKER EDDY

Out of personal loss, sickness and despair, Mary Baker Eddy found hope and health and in the process, inspired thousands through her groundbreaking philosophy and writings about science, health, faith and healing. Her ideas about the connections between mind and body and the power of prayer have proved to be prophetic, as quantum physics and medical science are now proving on a molecular level.

Born on a farm in Bow, New Hampshire, one of six children, Mary had her formal education often interrupted by periods of sickness. As a result, she spent many of her days at home, reading, studying and writing poetry and prose. Already a critical thinker at an early age, she rebelled against the tyranny of the Calvinist doctrine of predestination and instead of seeking solace in her deeply religious Congregational upbringing, regularly turned to her own interpretation of the Bible as her sole guide.

In 1843, Mary Baker married George Washington Glover, who died the following year, three months before the birth of her only son George. A

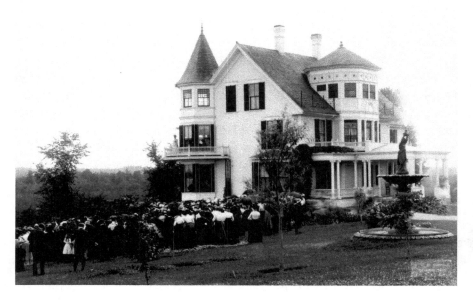

Mary Baker Eddy addressing followers from her balcony at Pleasant View in Concord. *Courtesy Mary Baker Eddy Library for the Betterment of Humanity.*

young widow, she returned to her parents' home until their deaths in 1849. Throughout this time, plagued by illness and alone, she found she could no longer care for her son and relinquished his care to the family's former nurse. In 1853, she married Daniel Patterson, an itinerant dentist who eventually deserted her. In 1866, Mary Baker divorced Patterson.

Widowed, childless, divorced and ill, Mary Baker sought help outside conventional nineteenth-century healing methods that often proved harsh with dangerous side effects. She tried alternative treatments like diet and hydropathy (water cure) and began avidly studying homeopathy, fascinated by the idea of diluting drugs to the point where they disappear from the remedy. One day when she decided to experiment with placebo pellets, she concluded that the belief of a patient had a powerful influence on healing.

When Mary Baker consulted with Phineas Quimby, a renowned healer in Portland, Maine, she improved radically for a time and began to study Quimby's methods and spent many hours discussing with him ideas about healing philosophies. In 1866, one month after Quimby died, Mary Baker

had a severe fall on an icy sidewalk that put her in bed in critical condition. She asked for her Bible and upon reading about the healings of Jesus, found herself suddenly healed. She referred to this turning point as the moment she discovered Christian Science.

In 1875, after many instances in which her own health problems were solved by spiritual healing, Mary Baker wrote *Science and Health*, the book in which she defined what she understood as the "science" behind the healings of Jesus. Mary Baker taught her system of healing to hundreds of people, who in turn began successful healing practices throughout the United States and beyond. In 1877, she married Asa Gilbert Eddy, one of her students who gave her constant support.

In 1879, disheartened by the rejection of her healing philosophies by existing Christian churches, Mary Baker Eddy started her own church— Church of Christ, Scientist, with a charter to "commemorate the word and works of our Master, which should reinstate primitive Christianity and its lost element of healing." In 1888, at the National Christian Scientist Association, she addressed an audience of four thousand.

As interest in Christian Science grew worldwide, Mrs. Eddy withdrew more and more from public appearances. From 1892 to 1908, Mary Baker Eddy lived and worked at Pleasant View, a home on the outskirts of Concord, New Hampshire, from where she did much of her most productive writing. She was known for legendary carriage rides that, while calling attention to this renowned yet mysterious woman, also provided her with her best prayer time.

When Christian Science meetings outgrew Hawthorne Hall and then Chickering Hall in Boston, the time came to build a home for the Christian Science Church. In 1894, the Swenson Granite Company of Concord quarried New Hampshire granite to build the Mother Church, a massive Romanesque building located at the corner of Huntington and Massachusetts Avenues in Boston's Back Bay, now Christian Science World Headquarters. Today there are two thousand branch churches in seventy-nine countries.

It is significant that Mary Baker Eddy came to her discovery in the middle of her life, at a time when women could not vote, were barred from most pulpits, seminaries and the medical profession. As an outsider, Eddy took the brunt of criticisms from those who considered her eccentric and controversial. In 1906, New York City newspaper mogul Joseph Pulitzer published a scathing front-page story about Mrs. Eddy that was largely fictitious. Stalwart to the end, at age eighty-seven, Mrs. Eddy responded to

this celebrated "yellow journalism" by founding the *Christian Science Monitor*, a newspaper designed "to injure no man, but to bless all mankind." It is both fitting and ironic that her internationally respected newspaper founded on fairness in journalism with the mission to cover major news and overlooked stories around the globe has eighteen bureaus worldwide and has won seven Pulitzer Prizes.[10]

GOVERNMENT, POLITICS AND WAR

First Incident in the Revolutionary War

In September 1765, Portsmouth colonists were so upset about the passage of the Stamp Act that they hung effigies of the local stampmaster in Market Square, and later paraded them around town and burned them. In October, *New Hampshire Gazette* editors organized a mock "mourning" of the Goddess of Liberty's death. Participants flew what is said to be the first revolutionary flag, which featured a snake and the phrase "Don't Tread on Me," from a "Liberty Pole" erected near the bridge at Puddle Dock, the site of Strawbery Banke today. At the end of 1774, the British placed new restrictions on gunpowder imports and inspired a more momentous revolt.

On December 13, 1774, Boston silversmith Paul Revere rode sixty miles from Boston to Portsmouth to deliver a letter to Captain Samuel Cutts of the New Hampshire Militia, who at the time lived on Market Street. The letter relayed information about a British warship that would soon be sent from Boston to Portsmouth Harbor, and about troops who would be arriving with instructions to remove all one hundred kegs of gunpowder, fifty muskets and sixteen small cannons from the site of Fort William and Mary in New Castle, or to take over the fort and defend it.

The next afternoon, on December 14, four hundred colonists calling themselves the Sons of Liberty sailed gundalows—flat sailing barges—down the Piscataqua River to Fort William and Mary. Captain John Langdon led the assault, and after a minor skirmish captured the fort and seized the guns and powder to deny the British. The colonists lowered a British flag for the first time, in what became the first overt military action of the colonists against the Crown.

That night the colonists stored the confiscated powder beneath the pulpit of the meetinghouse in Durham until a later time when the Patriot militia

Fort Constitution. *Photo credit E.W. Whitney III.*

might need it. In review of the night's escapade, it was determined that the colonists had failed to secure the muskets and small cannons. Consequently, the next night, five hundred colonists returned to the fort, this time led by John Sullivan, a Durham lawyer recently back home from a meeting as the New Hampshire representative at the Continental Congress. The men attacked the fort, and again faced little opposition, this time stripping it of all military provisions, including cannons, muskets and bayonets. Fort William and Mary was renamed Fort Constitution.[11]

FIRST STATE CONSTITUTION

In July 1774, when the Provincial Congress met initially to elect delegates for New Hampshire to send to the Continental Congress, Governor Wentworth denounced them, saying they were meeting "in open opposition to and in defiance of the Laws and his Majesty's authority."

Despite these admonitions, a small group of devotees that included Meshech Weare, Matthew Thornton, Ebenezer Thompson, Wyseman Claggett and Benjamin Giles continued to gather support, and within a year, membership of the Provincial Congress outnumbered that of the royal legislature. While

the Provincial Congress continued to pressure the governor, urging boycotts of British goods and creating a public forum for dissension against the British, Governor Wentworth expressed his loyalty to King George, and continued to stand behind British taxation and military policies.

By 1775, Wentworth found himself deserted by advisers and lacking support from British Parliament, with a legislature that had been rendered helpless. On July 14, 1775, the fearful governor fled Portsmouth and took temporary refuge at Fort Constitution before moving to a Loyalist stronghold in Boston. The departure of Governor Wentworth meant that royal government ceased to exist in New Hampshire, creating a political and governmental vacuum.

Certain individuals like Matthew Thornton, John Langdon and Josiah Bartlett felt the necessity to act expediently to form a formal government. On October 18, 1775, Langdon and Bartlett officially appealed to the Continental Congress for advice about how to proceed.

On November 3, the formal resolution came from the Continental Congress: "That it be recommended to the provincial Convention of New Hampshire, to call a full and free representation of the people, and that the representatives…establish such a form of government…[that] will best produce the happiness of the people and most effectively secure peace and good order in the province." With this official blessing, the Provincial Congress quickly called a fifth meeting, appointing a committee to draft a formal document.

On January 5, 1776, exactly six months before the Declaration of Independence was signed, the committee drafted the constitution and presented it for approval. As a piece of legislation, this state constitution was easily passed but not signed, but nevertheless became the first document of revolutionary America and the first state constitution in the new United States.[12]

EARLY ROOTS OF THE REPUBLICAN PARTY

For many years, historians, beginning with Henry Wilson, vice president under Ulysses S. Grant, credited Ripon, Wisconsin, as the official birthplace of the Republican Party, formed in 1854. Today there is a little white schoolhouse marking the event, and ten thousand visitors tour the site each year. But according to extensive documents connected to "Three-term Tuck," a three-term congressman from Exeter, the birth of the Republican Party actually happened roughly six months earlier.

On October 12, 1853, Amos Tuck called a secret meeting in Exeter at Major Blake's Hotel (later the Squamscott Hotel, now Gorham Hall) of fourteen leaders from the Independent Democrats, Whigs, Free Soil and American or Know-Nothing Parties. All agreed to give up their formal allegiances to unite under the principles of Democratic-Republican Thomas Jefferson. At Tuck's suggestion, they named themselves Republicans—a pivotal moment that signified the culmination of ten years of work.

More than a decade earlier, in 1842, just as Amos Tuck was elected as a Democrat to the New Hampshire House of Representatives, his friend John P. Hale was denied his bid for re-nomination to Congress by Democratic Committee Chairman Franklin Pierce because of Hale's antislavery sentiments and his consequent opposition to the annexation of Texas. Pierce, who had been actively campaigning across New Hampshire against Hale's nomination, met opposition from John L. Hayes of Portsmouth and David A. Gregg, Henry F. French, N. Porter Cram and Amos Tuck of Exeter, who all supported Hale.

In 1844, Tuck broke with his party on the question of slavery and was formally cast out of the Democratic Party. On January 7, 1845, Congressman John P. Hale wrote his famous letter addressed to "Democratic-Republican electors" explaining his opposition to the annexation of Texas because it would result in the expansion of slavery.

On February 22, 1845, in the vestry of the First Congregational Church in Exeter, Tuck called a convention to form an independent body in support of Hale, obtaining 263 signatures. The meeting solidified opposition to slavery, and was referred to by Tuck in the *Exeter News-Letter* in 1876 as "the first successful [anti-slavery] rebellion anywhere in the country," which constituted collective support for Hale as candidate for United States senator under the abolitionist coalition named by Hale and Tuck as "Independent Democrats."

On May 1, 1845, Tuck began to publish a newspaper of the same name. Enthusiasm for the Independent Democrats culminated on July 4, 1845, at a rally where two thousand people gathered in Moultonborough. In 1846, Hale defeated John Woodbury for the Senate seat. In 1847, Tuck was elected to Congress. It was during this term in Congress, from 1847 to 1853, that Tuck formed a strong friendship with a quiet man from Illinois—Abraham Lincoln.

In his article "The Emergence of the Republican Party in New Hampshire, 1853–1857," Thomas R. Bright wrote, "There was no appreciable distinction between the Republican of 1857 and the Free Soil and Whig coalition of 1853...The 1856 national campaign provided an image and a name for a coalition already many years old."

On February 22, 1845, Congressman Amos Tuck gathered together an abolitionist coalition at the First Church of Exeter, with preliminary plans to found the Republican Party. *Photo Credit: E.W. Whitney III.*

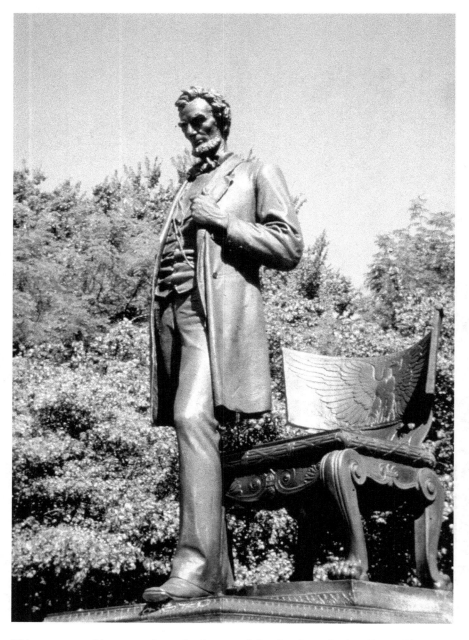

This monumental bronze sculpture by Augustus Saint-Gaudens, *Abraham Lincoln: The Man*, dedicated in 1887 in Chicago, has always been known as the "Standing Lincoln" to distinguish it from Saint-Gaudens's other Lincoln sculpture in Chicago that depicts the president seated, *Abraham Lincoln: The Head of State*. Grant Park, 1906. *Courtesy Augustus Saint-Gaudens National Historic Site.*

In 1860, Tuck led the New Hampshire delegation at the Second Republican Convention in Chicago. Due to the leadership of Tuck, New Hampshire was the only New England state to cast a majority of votes to give Lincoln the Republican nomination.[13]

That same year, John Milton Hay, son of a rural Illinois doctor and recent graduate of Brown University, was clerking in his uncle's law office in Springfield, Illinois, when he met President-elect Abraham Lincoln. Lincoln's secretary John G. Nicolay insisted that Hay accompany them to Washington, at which point Lincoln hired the twenty-two-year-old Hay as his private secretary. Upon the assassination of Lincoln, Nicolay and Hay wrote a formal ten-volume biography of Lincoln, *Abraham Lincoln: A History*, published in 1890. Hay went on to become ambassador to Britain and secretary of state under Presidents William McKinley and Theodore Roosevelt. John Hay and his wife, Clara Louise Stone, sought refuge from public life on the shores of Lake Sunapee and in 1888 began acquiring abandoned farms that eventually amounted to approximately one thousand acres. Their estate, now a National Historic Site in Newbury, New Hampshire, was named the Fells after the Scottish word for "rocky upland pastures."[14]

LARGEST STATE LEGISLATURE

On January 5, 1776, the Fifth Provincial Assembly of the state of New Hampshire ratified the first-in-the-nation state constitution, under which the state was governed until the current constitution was adopted in 1784. From its beginnings, the New Hampshire government consisted of a twelve-member Senate and a House of Representatives, the size determined by the population, with each member representing one hundred citizens.

In 1877, the Senate doubled in size to twenty-four members as the House continued to grow until 1943, when a constitutional amendment limited its size to four hundred. As such, the New Hampshire House of Representatives remains the largest state legislative body in the United States, and the third largest legislative body in the English-speaking world. Only the U.S. House of Representatives and the British Parliament are larger.

The remuneration for House members has remained unchanged at $200 per two-year term since 1889, ensuring that the Granite State continues to be governed by what is, by all intents and purposes, a volunteer citizen–based legislature. As Richard Leavitt stated in his book *Yesterday's New Hampshire*, "One advantage of its unwieldy size is that it makes corruption non-existent—unless you call it corruption to swap a vote for a ride home."

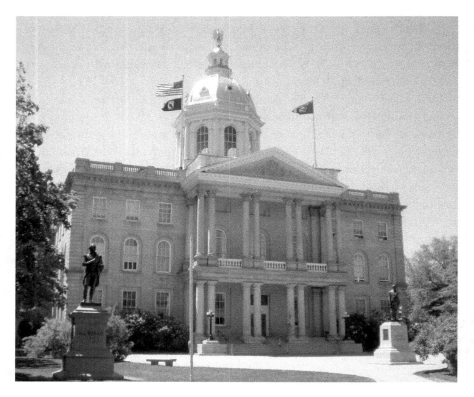

The New Hampshire State House, Concord, New Hampshire. The sculpture on the left is Major General John Stark; on the right, Daniel Webster. *Photo Credit: D. Quincy Whitney.*

The New Hampshire State House, built in 1816, was doubled in size twice in its history, first in 1864 and then in 1909. Each time, the legislature still met in its original chambers. Currently, it can be claimed that, in that way, New Hampshire's remains "the oldest state house in the nation with the legislature still meeting in its original chambers."[15]

According to Walter Sword, protective services and New Hampshire State House doorkeeper, there are a few interesting hidden facts visitors to the State House might find interesting. The first concerns the New Hampshire state license plates—white with red numbers. Each plate is an identification plate for each representative. The first number indicates one of five sections in the house; the second number indicates the seat number. Each representative presently represents just 3,300 people, mandated by the present population divided by 400 representatives, reevaluated by the census taken every decade. There are five sections of house seats but, surprisingly, they number 404 instead of the anticipated 400. This is because there are

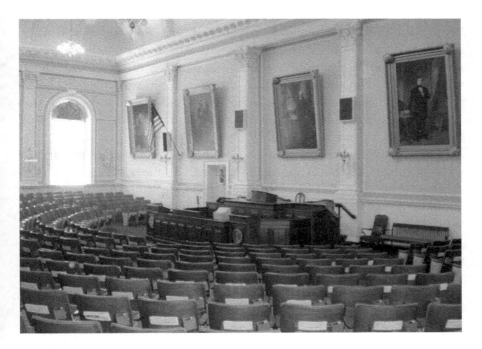

The New Hampshire State House Chambers. The portraits (left to right) are of John
P. Hale, Abraham Lincoln, George Washington and Franklin Pierce. The fifth portrait,
unseen, is of Daniel Webster. *Photo Credit: D. Quincy Whitney*.

no seats numbered "13"—a phenomenon that goes back to the building of
the chambers. In addition, the Speaker of the House has no assigned seat.

First International Peace Treaty Signed in the United States

At its best, diplomacy is a many-splendored thing. Informal conversations
often oil formal negotiations. Nowhere was this idea more dramatically
proved than in the signing of the Portsmouth Peace Treaty on September
5, 1905, at 3:47 p.m. at Portsmouth Naval Shipyard, earning President
Theodore Roosevelt the 1906 Nobel Peace Prize. In the epitome of
indirectness, the president won what may be the most coveted prize in the
world by *not* being present.

The Russo-Japanese War of 1904–05 was a conflict between Russia, an
international powerhouse hosting one of the largest armies in the world,
and Japan, a tiny nation trying to emerge from two centuries of isolation.

Paradoxically, the two nations fought over and only on two neutral nations, China and Korea. Prior to World War I, this conflict involved the greatest battles committing substantial numbers of troops and ships, initiating the era of modern warfare after the invention of machine guns, barbed wire, illuminated shells, mine fields, advanced torpedoes and armored battleships. Had this conflict gone unchecked, it might have easily escalated into a world war.

Having served as assistant secretary of the navy, Roosevelt was familiar with the Portsmouth Naval Shipyard and thought it the perfect place to host delicate negotiations. Captain Jonathan Iverson, the shipyard's commander in 2006, the centennial year of the treaty signing, explained: "Placing his trust in the navy, President Roosevelt was confident that Portsmouth Naval Shipyard's military leadership would properly execute the international protocol, attention to detail and security required for this global event." While Roosevelt stayed out of Portsmouth during negotiations, he worked "back-channel" diplomacy from his summer home in Sagamore Hill, Oyster Bay, New York.

The U.S. Navy converted the second floor of Building 86 into negotiating rooms where the treaty was eventually signed. Mahogany furniture in the style of that used in the Cabinet Room of the White House was ordered from Washington. The large conference table where the treaty was signed is preserved today at the Museum Meiji Mura in Inuyama, Aichi Prefecture, Japan. Wentworth-By-The-Sea donated accommodations to the full Japanese and Russian delegations for the entire thirty-day conference. Delegates were ferried back and forth across the Piscataqua River and the back channel from their accommodations at Wentworth-By-The-Sea in New Castle, New Hampshire, to the Naval Shipyard in Kittery, Maine.

While Roosevelt practiced backyard diplomacy, the citizenry of Portsmouth embraced front yard diplomacy. In fact, is it now recognized that the informal hospitality of the city of Portsmouth and the state of New Hampshire actually had a significant role in creating an atmosphere conducive to a formal peaceful settlement.

On August 8, the steamer *Mineola* ferried a Portsmouth welcoming committee to greet delegates arriving at the train station. A welcoming parade was followed by a reception held at the Rockingham County Courthouse, hosted by Governor John McLane. Throughout the conference, a diverse array of social receptions followed at twenty-five different locations around Portsmouth. Delegates and correspondents were entertained at the Music Hall. Boston's Tenth Artillery U.S. Band stationed at Fort Constitution gave public concerts

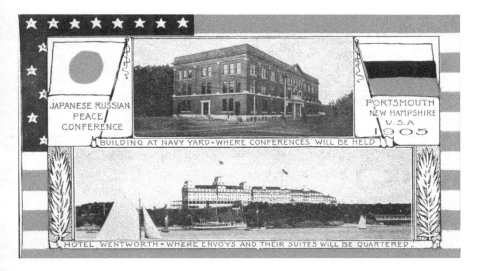

Postcard commemorating the cooperation between the Portsmouth Naval Shipyard and Wentworth-By-The-Sea in hosting the 1905 Japanese-Russian Peace Conference. *Courtesy Portsmouth Peace Treaty Forum/CB Doleac Collection.*

and also performed for envoys at parties and state dinners. The former YMCA and the Portsmouth Athletic Club hosted visits from delegates. Jewish émigrés living at Strawbery Banke reached out to Russian delegates. Dr. and Mrs. Heffinger held a reception and ball for the Russian delegation at their home. Governor McLane and the New Hampshire delegation hosted a luncheon for Japanese delegates at Derryfield Club in Manchester. The Japanese delegation toured the Amoskeag Mills in Manchester. The Carey family hosted both delegations several times at their summer home, Creek Farm. A local resident loaned his home, Niles Cottage, to assistant secretary and Mrs. Herbert Peirce, who held state dinners for both delegations.

Upon hearing that the signing of the peace treaty would take place at the Portsmouth Naval Shipyard, Sarah Farmer sent written invitations to all three delegations—American, Japanese and Russian—to attend a special celebration at Green Acres, the Bahai School and retreat center she had founded in 1894 on the banks of the Piscataqua River in Eliot, Maine. Though President Roosevelt and Ambassador Witte declined, citing scheduling problems, the Japanese delegation accepted. On August 31, 1905, at Green Acres, Japanese Minister Takahira, Dr. Kahn and Sarah Farmer addressed an audience of more than three hundred guests on the subject of peace.

Delegates signing the Portsmouth Peace Treaty were Sergius Witte and Roman Rosen for Russia and Komura Jutaro and Takahira Kogoro for Japan. Among Americans present were Governor John McLane, Mayor

Marvin, Admiral Mead and Sarah Farmer, thought to be the only woman present at the signing.[16]

FIRST PRIMARY IN THE NATION: THE BALSAMS

It would be hard to imagine a more paradoxical town in New Hampshire than Dixville Notch. Every four years one of the smallest towns in the Granite State attracts national attention because, since 1960, it has been the first community to vote for president in the first-in-the-nation presidential primary. But the vote—and the hubbub—does not happen at town hall.

"Most of the journalists arriving for the first time admit they knew nothing of this massive European-style hotel that sits at the base of the Notch," said Steve Barba, former president and managing director at The Balsams Hotel from 1971 to 2005. Barba wanted it that way. "I will never forget watching a journalist step way away from the main entrance of the hotel to a background of snow and woods to begin his nostalgic first line: 'I am *live* here in downtown Dixville Notch.' The only problem is there *is* no downtown! Downtown is The Balsams Hotel," recalled Barba, who began his long association with The Balsams as a thirteen-year-old attending caddy camp.

For an event that remains the epitome of spin, Barba wanted no spin at all. Barba wanted to take the politicking out of politics at Dixville Notch. A catalyst for his adamant position on how politics would be run at the hotel occurred in 1968. Former Governor George Romney kicked off his 1968 bid for the Republican Presidential Nomination by staging a photo op in the ballroom that showed him helping his wife onto an elephant—a real seven-hundred-pound *live* elephant named Popsicle!

"When a Democrat who had seen Romney with the elephant decided he would go find himself a donkey, my partner followed him and shut down the elevator so he could *not* bring a donkey into the ballroom," recalled Barba in a recent interview at Plymouth State, where he is now executive director of university relations.

The image of a politician with an elephant in the ballroom did it for Barba. By 1971, when he became managing director, most of the few residents of Dixville Notch worked at The Balsams. Barba wanted to prevent candidates from seizing the opportunity to campaign directly to staff.

Barba explained,

> As the primary became more and more a media event, I did not want
> to prostitute the event. I was very careful to keep it a serious, pristine

*event—no gifts to voters, no news releases, no special accommodations,
no special attention paid to particular candidates, no hype, no wild
campaigning. Each candidate would be treated the same, have the same
amount of time to meet people and have the same food served to them.
I wanted the hotel and its personnel to maintain a neutrality about this
most significant and important event.*

Each year Barba set up the Tote Board—a painted white wooden sign
with the current candidates listed. He built eighteen separate voting booths
so everyone could vote at exactly a minute past midnight. Voters drew lots
to see who got to cast the first ballot.

The photograph of Romney and the elephant hangs in the infamous
Ballot Room—a secluded, wood-paneled room with a fieldstone fireplace—
situated in the back corner of The Balsams Hotel, the farthest point from
the Notch that gives it its notoriety. The Ballot Room is open to the public
and holds a fascinating array of photographs and other memorabilia
crammed gallery style on all four walls.

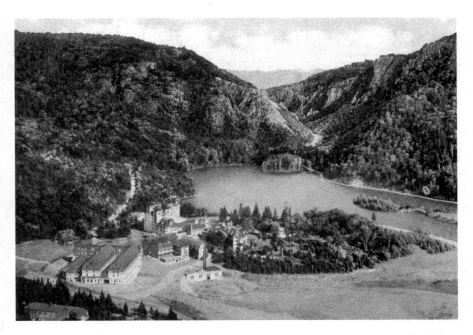

View from Mount Abenaki, showing The Balsams, Lake Gloriette and Dixville Notch,
New Hampshire. *Collection of Steve Barba.*

The Tote Board in the corner displayed the 2008 primary vote tally:

Guiliani—1	*Clinton—0*
Huckabee—0	*Edwards—2*
McCain—4	*Kucinich—0*
Paul—0	*Obama—7*
Romney—2	*Richardson—1*
	Thompson—0

Other memorabilia in the Ballot Room aptly convey widely diverse aspects of American political life. There is a 1960 photograph of a very young William Clinton visiting the Ballot Room as the guest of Governor Hugh Gallen. There is a December 1982 *National Geographic* cover featuring Neil Tillotson, Dixville's centenarian town moderator and former Balsams general manager, who had been the first voter in America since 1960. Another photograph epitomizes the fact that any candidate, no matter how strange or quirky, could get an audience at Dixville Notch. In this photograph, Arthur O. Blessit, an evangelist street preacher, a precursor to the Christian Right, campaigned in 1976 by dragging a huge wooden cross on a large wheel wherever he traveled.

There is a framed red-and-black plaid shirt worn by former Tennessee Governor Lamar Alexander during his one-hundred-mile walk across New Hampshire, presented February 5, 1996, to the voters of Dixville Notch out of respect and appreciation for their national role in choosing American presidents. A cartoon shows a voting room with one person, which says, "No, we aren't experiencing low voter turnout. Everybody's here."

"Dixville Notch is a very small community in a very remote place in America where candidates are tested in a way that is authentic. There is a nakedness to the process that reveals character," said Barba.[17]

First International Monetary Summit: The Mount Washington Hotel

Imagine a global town meeting—lasting for three weeks! That is exactly what happened at the Mount Washington Hotel in Bretton Woods, July 1–22, 1944, within a few weeks of the D-Day Normandy landing and Hitler's bombing of London.

The fact that the first—and only—International Monetary Conference managed to establish the World Bank and the International Monetary

Fund; set the gold standard at thirty-five dollars an ounce; and set the value of other currencies to the U.S. dollar is actually a miracle, considering that the conference had all the engaging complexities of even the smallest town meeting. The only difference was that the innuendoes, ambiguities, confusion, abstractions, jockeying for position, intense arguments and ultimate compromises ensued between the delegates of forty-four nations.

But first, the historic hotel at the foot of Mount Washington had to get ready to receive seven hundred guests. As Armand Van Dormael wrote in his book *The Bretton Woods Conference: Birth of a Monetary System*, "In addition to the official delegates, there were advisers, assistants, stenographers, newsmen, observers, technicians, and so on. Many of them spoke no English at all. The trains that brought them to Bretton Woods were dubbed 'the Tower of Babel on wheels.'"

When the Mount Washington Hotel opened on July 28, 1902, it was the largest wooden structure in New England, located in the heart of the Presidential Range in the one-million-acre White Mountain National Forest. In fact, the government had chosen Bretton Woods, New Hampshire, as the site of the conference for security reasons because it was so remote. As Van Dormael wrote, "Bretton Woods, the postal address of the hotel, was only a stop on the railway. It had no store, not even a main street. The hotel was self-sufficient with its own power plant, dress shops, beauty parlor, bowling alleys, barber shop, and stock ticker-tape. There were two cinemas, a swimming pool, tennis courts, and stables. A church was located in the hotel grounds."

Joseph Stickney, a New Hampshire native and coal and railroad mogul, founded the hotel that was designed by Charles Alling Gifford in the tradition of the Spanish Renaissance—pearl white with a red roof to imitate Spanish tile roofs.

But by the time of the conference, the grand hotel had been closed for two years because of the war. With just two months to prepare, the government brought in 150 workers—including enlisting a group of Army Military Police who outworked the hired help—to overhaul the hotel that has two thousand doors and twelve hundred windows. Roofs had collapsed under heavy snow, wallpaper was peeling off the walls and everything was in need of a coat of paint. As the *Walking Tour* guide booklet states, "Each worker got 50 cans of white paint, and was told if it didn't move, they should paint it white—which is what they did! They painted all of our beautiful mahogany doors white, the brass light fixtures in the Great Hall and even some of the Tiffany windows."

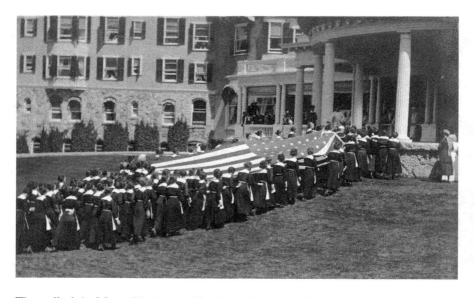

The staff of the Mount Washington Hotel unfurled a gigantic American flag as part of the welcoming ceremonies of the Bretton Woods Monetary Conference, held at the hotel July 1–22, 1944. *Courtesy Mount Washington Hotel.*

According to Van Dormael, "The extraordinary bustle and confusion regarding the allocation of rooms, complicated by the lack of staff, hot water, beds, and so on, caused at least one casualty on the first day of the conference: the news went around that the new manager of the hotel had either drunk himself out of his job, or else had given up in despair and left."

Led by U.S. Secretary to the Treasury Henry Morgenthau Jr. and his key negotiator Harry Dexter White and Britain's Lord Keynes, the international town meeting could begin. After a message relayed from President Roosevelt, who purposely did not attend, Chinese, Czechoslovakian, Mexican, Brazilian, Canadian and Russian delegates spoke. The issues were many and the voices were loud. Countries jockeyed for position to obtain larger quotas; squabbled over the amount of gold to be subscribed, voting power and the degree of flexibility of exchange; and disagreed over the pressure on debtor and creditor countries.

Henry Morgenthau Jr. said, "We can accomplish this task only if we approach it not as bargainers but as partners—not as rivals but as men who recognize that their common welfare depends, in peace as in war, upon mutual trust and joint endeavor."

Still, the issues were not only controversial but were often shrouded in a language puzzling even to professional economists, full of technicalities way beyond the comprehension of most congressmen. William Keegan observed, "In the end, obfuscation and ambiguity played a vital role in enabling the Bretton Woods agreement to be ratified by Congress and Parliament."

Eileen Savoy, current adventure desk manager of the hotel, remarked, "So many people from this state do not know about the Monetary Conference yet each year many people come here from all over the world to revisit the hotel they knew in 1944."[18]

First and Only "Altar of the Nation": Cathedral of the Pines

The Cathedral of the Pines located on "Halo Hill" overlooking Mount Monadnock in Rindge, New Hampshire, is all about transcendence. First, the transcendence of nature surrounds the visitor entering this cathedral without walls. A central aisle through columns of majestic pines leads to a stone altar on the crest of a hill. The lofty domed ceiling of the cathedral is the sky. When the weather dictates, a halo of mist rises from the three separate bodies of water circling the knoll, hovering over it in the early hours of the morning. On these days when the rays of sun strike the mist, a rainbow circles the knoll—a halo of color, a sign of blessing on this place, if ever there was one. Indeed, relics found on the property suggest this knoll was once sacred to Native Americans.

But the Cathedral of the Pines is also a place where the land transcends itself. Unlike any other place in the state, the nation and perhaps the world, Cathedral of Pines is an international icon much larger than the knoll on which it stands—a place created out of the loss and vision of one man and his wife: Douglas Sloane and his wife Sybil.

Serendipity brought the Sloanes from Port Chester, New York, in search of a summer home to Rindge, despite the fact that they determined they would never live in New Hampshire. But on October 16, 1937, they bought the old Hale farm without even walking the bounds. Then the hurricane of 1938 revealed something more than a jungle of old pines on a hill—a stunning view of Mount Monadnock. Douglas Sloane recalled the day after the hurricane when he and his wife plowed through pine needles eighteen inches deep and climbed atop "a stepladder" of four huge, fallen pines: "We looked out and over. We could not speak. We suddenly realized this spot must be shared." They planned to make an outdoor chapel.

The Sloanes had four children: a daughter Peggy and sons Sandy and Jack, first lieutenants and pilots stationed in Germany and Italy. The eldest, Douglas IV, had been refused admission to the Army Air Corps because he was treasurer and general manager of a company that manufactured vital war supplies. Each had picked a location on the farm to build a house. Sandy had picked the wooded knoll for the view to the south overlooking Emerson Pond.

On February 22, 1944, the Sloanes received news that Sanderson Sloane, pilot of a B-17 bomber, had been shot down over Germany and was missing in action. When days turned into months, they began to make plans for an outdoor chapel to be placed right on the spot where Sandy had dreamed of a home. In August 1945, the Sloanes put the word out to a few friends and neighbors that they were going to have a service at the edge of the knoll under the pines, in the spirit of the "Chatauqua-style" services a neighbor had held on his hayfield years earlier. On a Sunday in August, as they were about ready to have the service at 4:00 p.m., a cloudburst postponed it for a few minutes, time enough for the Sloanes to see a long cavalcade of cars moving up the road coming onto the field. When he saw this outpouring of support, Sloane made immediate plans to build the outdoor chapel he

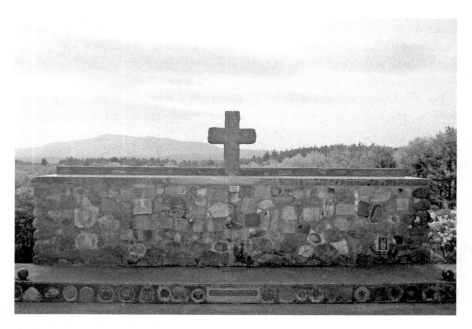

Embedded in the Altar of Nations are stones from privates, generals and presidents honoring all American war dead. *Courtesy Cathedral of the Pines.*

had long envisioned. Pegs, Sandy's widow, who was pregnant, selected the place for the fieldstone altar behind which was a natural reredos of Mount Monadnock.

Sloane, a member of the Sons of the American Revolution, asked Harry E. Sherwin, New Hampshire SAR state secretary, to request all the other state societies to send rocks from their respective states to place in the proposed fieldstone altar. Sloane explained the reason for the stones:

> *Hundreds of tons of rock being used for foundations and appointments themselves came from the stock pile gradually built by generations of farmers clearing the land. These rocks, therefore, symbolize a determination for better living, for freedom, and for independence. Men had gone from this farm and from similar farms along the eastern seaboard to populate other states. It seemed fitting and proper to ask descendents of those Pioneers to send back tokens, to bed in with those dug from this land, to express the unity and strength of a grateful nation honoring all her war dead.*

The tradition grew to include stones and medals from around the world. In 1967, one appreciator described the roll call as "an offering of stones" from privates and heads of state, from generals and admirals, from the concentration camps of Nazi Germany and from a bombed-out cathedral in Europe. Presidents Truman, Eisenhower, Kennedy and Johnson and every president since has offered stones that have been added to the "Altar of the Nation."

On September 8, 1946, the Altar of the Nation was dedicated a "memorial to the World War II Dead of New Hampshire and as a shrine of the Society." On September 7, 1947, the altar was rededicated as a memorial to the American war dead of World War II. In response to the requests of many people around the world, on August 13, 1950, the Altar of the Nation was dedicated a memorial to all American war dead. In January 1957, the United States Congress unanimously voted recognition of the Altar of the Nation in the Cathedral of the Pines as a memorial for all American war dead.[19]

INGENUITY AND ENTERPRISE

Early School for Native Americans

"I made a hutt of loggs about 18 feet square, without stone, brick, glass or nail...My sons and students made booths and beds of hemlock boughs." So states Congregational minister Eleazar Wheelock about the school for Indians he founded—the first building of Dartmouth College in Hanover.

In 1733, Wheelock graduated from Yale and was ordained and called to the Second Parish, Lebanon, Connecticut. Originally to supplement his income, Wheelock opened a boys' school in the parsonage. A Monhegan youth, Samuel Occom, was one of his students. According to Barbara Brown Zikmund in her book *Hidden Histories in the United Church of Christ*, his experience with Occom inspired Wheelock to conceive "the idea of a school and mission where Indian boys and white boys would be trained together. The Indian boys would learn English and be introduced to Christianity and the skills of white society. The white youths would learn Indian vernacular and the ways of Indian life. Later the youth would be paired in the mission enterprise with remote tribes and sent out to establish churches and schools."

With this ambitious vision, Wheelock was sent Delaware and Monhegan youth, and in 1755 he established the Moor-Indian Charity School at Lebanon, Connecticut. According to Zikmund, "All students were on scholarships. By 1765, he had enrolled twenty-one Indian boys, ten Indian girls, and seven white boys."

When funds depleted with the decline in Indians attending, Wheelock looked north to unsettled lands and moved to Hanover in the Royal Province of New Hampshire. John Wentworth, the royal governor of New Hampshire, provided the land upon which Dartmouth would be built.

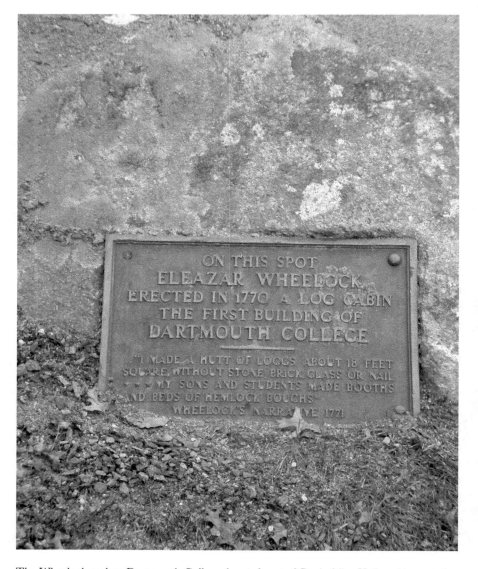

The Wheelock rock at Dartmouth College, located east of Rockefeller Hall and just north of Russell Sage/Butterfield Hall. *Photo Credit: D. Quincy Whitney.*

On December 13, 1769, King George III conveyed the charter to establish the college "for the education and instruction of Youth of the Indian Tribes in this Land…and also of English Youth and any others," naming it for William Legge, the second earl of Dartmouth, who had been

one of Wheelock's proponents. Dartmouth became the ninth oldest college in the nation and the last institution of higher learning created under colonial rule. Occom was instrumental in raising funds for the new college.

Wheelock was, first and foremost, a Calvinist for whom the wrath of God was real. He had contempt for the Indian culture—a shared view of his people and his time—and felt that conversion was easier, more effective and cheaper in loss of lives and money than the coercion of military conquest, and that the tendency of Indians to keep treaties depended on civilizing them, which in his view meant "Christianizing" them.

Though the premise of his zeal was obviously misguided, the results were far from it. Wheelock was a visionary who became the first president of Dartmouth, a trustee, professor of divinity and minister of the College Church, devoted to the school he carved from the wilderness. Wheelock was a businessman ahead of his time as well, forging crucial political alliances during the Revolutionary War that enabled him to keep the school running, making Dartmouth one of the few American colleges to have continually graduated a class since 1771.

The Dartmouth legacy involving Native Americans has taken many forms over the years. One of the college's greatest treasures—and one of the most spectacular murals in the nation—resides on the walls of the bottom floor of Baker Library in the center of campus. *The Epic of American Civilization* by Jose Clemente Orozco, painted between 1932 and 1934, features haunting imagery and provocative themes that still resonate with audiences today. Orozco conceived of the mural as a series of images structured around an "American idea," specifically the depiction of a continent characterized by the duality of indigenous and European historical experiences.

Today Dartmouth nurtures its Indian legacy through the Native American Program, founded in 1970, which strives to provide spiritual, emotional and personal support for Native American students. Since the first decade of the program, when the graduation rate for Native Americans was 50 percent, the rate has risen to 72 percent, nearly ten times the average graduation rate for Native Americans attending college nationwide. Currently, 157 Native American students are enrolled from more than 50 tribes.

In 1971, Native Americans at Dartmouth sponsored its first powwow, one of six traditional events allowed to commence on the Green. This annual event is second largest in the Northeast, second only to Schemitzun, an event sponsored by the Mashantucket Pequot Nation.[20]

CONCORD COACH: STAGECOACH OF THE NATION

Lewis Downing believed in working hard and saving money. He said, "My advice is, mind your own business…Honesty, industry, perseverance and economy will assure any person with ordinary health a good living and something for a rainy day."

A native of Lexington, Massachusetts, Downing arrived in Concord, New Hampshire, around 1800 with his wheelwright tools and sixty dollars he had saved from working in his father's blacksmith shop. Within six months, Downing had built his first buggy. By the second year, he had hired two assistants. While the average newspaper advertisement touted miracle cures, Downing's April 1816 ad touted quality and price: "Lewis Downing, has constantly on hand…small wagons which he will sell as cheap as can be bought, and warrant them to be well made and of the best materials."

In 1826 Downing asked coach builder J. Stephen Abbot of Salem to oversee the building of three coaches. A year later, an inn in Salisbury purchased the first Concord Coach. On January 1, 1828, the partnership between Abbot and Downing became official.

In 1829, there were seventy-seven stagecoach lines out of Boston. Downing became the premier coach builder because he paid meticulous attention to every detail of the Concord Coach. He chose oak for the coach frame and body because of its hardness and durability and it was said that the woodwork of the Concord Coach outlasted the ironwork. No coach left Downing's shop without his personal approval. According to former employees, if any part proved unacceptable, Downing would, without a word, break the part so it would have to be remade. Concord Coaches were also beautiful: distinctive red coaches with yellow running boards embellished with emblems and hand-painted figures and "Aladdin's cave" interiors accented by wood paneling, fine leather and polished metal.

The renowned Concord Coach soon headed west and eventually became the stagecoach of the nation. In 1868, the *Concord Daily Monitor* reported, "A special train of fifteen flatbed cars, containing thirty elegant coaches from the world-renowned carriage manufacturer of Messrs. Abbot, Downing & Co…all consigned to the Wells, Fargo & Co., Omaha and Salt Lake City, the whole valued at $45,000…the largest lot of coaches ever sent by one manufactory at one time, probably…and no two of the thirty are alike." In the Museum of New Hampshire History, an oil painting by John Burgum dated April 15, 1868, entitled *An Express Freight Shipment of 30 coaches By Abbot, Downing & Co., Concord, NH, to Wells, Fargo Co., Omaha, Nebraska* depicts this historic shipment of Concord coaches to Wells Fargo.

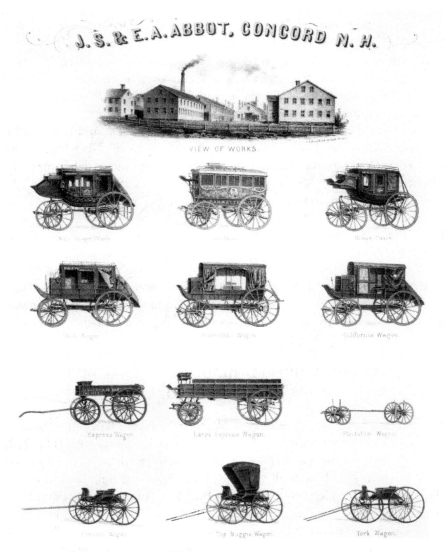

Lithograph advertisement, circa 1860, for various vehicles made by J.S. and E.A. Abbot of the famed partnership of Abbot-Downing. Concord Coaches are upper left and upper right. *Courtesy New Hampshire Historical Society.*

Abbot-Downing built the Deadwood Stage Coach exhibited by Buffalo Bill in his Wild West Show that toured throughout the world in the 1890s.

The elegance of the Concord Coach was so beguiling that White Mountain visitors made elaborate mountain tours in coaching parades

that attracted thousands. The Concord Coach in the Museum of New Hampshire History appeared in the 1939 New York World's Fair.

By 1847, though Abbot and Downing had built over seven hundred coaches, their famous partnership dissolved into eighteen years of intense rivalry. But in 1865, upon the retirement of Downing, the sons of Abbot and Downing incorporated as Abbot-Downing & Company.

A nine-passenger Concord Coach made in 1855 by J.S. and E.A. Abbot, Concord, sits regally in the center of the Museum of New Hampshire History in Concord, one example of the three thousand coaches made by Abbot-Downing by 1899.

Mark Twain described the Concord Coach as "an imposing cradle on wheels." The secret of the legendary smooth ride was the suspension system. Instead of riding on spring-like metal suspensions that bounded harshly up and down, the Concord Coach rode on riveted leather strips that gave the coach a swinging motion, inspired by the "thoroughbraces" suspension used in European coaches since the sixteenth century. In 1945, Wells-Fargo paid the highest tribute to Mr. Downing by purchasing the corporate name Abbot-Downing to preserve the legacy of the Concord Coach.[21]

Oldest Covered Bridge and Longest Covered Bridge

The covered bridge still standing at Woodsville, New Hampshire, built in 1829, is believed to be the oldest covered bridge in the country. The 278-foot-long bridge connects NH 135 in Bath on the north to NH 135 on the south in Haverill at Woodsville Village. The bridge was built using a lattice plan designed by Ithiel Town, at a cost of $2,400. An unusual feature of the bridge is a bench that runs the full length of the bridge on the inside wall of its 6-foot-wide sidewalk, a feature that is not original. The sidewalk, arches and entryways have been added since the bridge's original construction. In 1973, the bridge was repaired at a cost of $40,000.

The Cornish-Windsor Bridge, built in 1866, is thought to be the longest covered bridge in the country. The bridge connects the east end of Bridge Street in Windsor, Vermont, with NH 12A in Cornish, New Hampshire. Erected by Cornish resident James F. Tasker, also using the Town-patented design, the 460-foot-long bridge features two spans measuring 203 feet, 7 inches, and 204 feet, 6 inches, respectively, actually 6 inches shorter than the North Blenheim, New York bridge, ostensibly the longest single-span

The Cornish-Windsor covered bridge, Cornish, built 1866. *Photo Credit: D. Quincy Whitney.*

covered bridge in the world. However, the Windsor Bridge is longer because of its timber latticework that reaches considerably beyond its abutments. A distinctive feature of this bridge is the group of eighteen small square windows with hoods that extend the length of the bridge.

New Hampshire has its own distinctive "Paddleford"-style covered bridge, named after its inventor Peter Paddleford of Littleton, New Hampshire. In his design, Paddleford modified the Long truss plan originated by Colonel Stephen H. Long by superimposing panels to stiffen the trusses, a design that became known as a Paddleford bridge. The first Paddelford bridge is reported to be the one still standing that connects Redstone and Center Conway, owned by the town of Conway.[22]

TALLEST SHAKER DWELLING

The Great Stone Dwelling in Enfield, New Hampshire, is the largest domestic dwelling in the Shaker world, though other Shaker communities built barns and "outside buildings" that may have been larger.

The Great Stone Dwelling, Enfield Shaker Village. *Courtesy Enfield Shaker Village.*

Built in 1837, this building overlooking Mascoma Lake is one hundred feet high, from the top of the cupola to the ground, by fifty-eight feet wide, with four stories rising above the basement. Inside, three flights of stairs boast a continuous curvature of black cherry balustrades running nearly one hundred feet.

If stillness had an expression in American architecture, it might be a room in the Great Stone Dwelling. There are no words or images on the cream-colored walls, just long wooden sentences of Shaker pegs interrupted by colorful columns of built-in drawers—860 of them—and 200 twenty-pane windows inviting light within. The uncluttered space leaves room for thinking.

Enfield Shaker Elder Caleb Dyer noted, "Not one cent was owed on it when it was first occupied on June 8, 1841." In 1853, in his book *Fifteen Years in the Senior Order of Shakers*, Elkins stated, "Such a dwelling, as the one I have described, could not be erected in one of our cities for less than one hundred thousand dollars; but as the quarry of stone, and forests of pine, whence its materials were extracted, are owned by the family who erected it, they probably expended in cash not more than half that sum."

Today the Great Stone Dwelling is open year-round and is available for private parties, conferences and seminars.[23]

LARGEST STEREOSCOPIC VIEW COMPANY IN THE WORLD

Despite their work experience in the foundry owned by their father Josiah Kilburn, where they helped market plows, cultivators and stoves, sons Benjamin and Edward Kilburn were much more fascinated by photography. In 1867, they founded the Kilburn Stereoscopic View business in Littleton, New Hampshire, which by 1893 had become the largest company of its kind in the world.

Sylvester Marsh with "Peppersass," the first mountain-climbing train on Mount Washington. Stereoscopic view no. 183, the Kilburn Brothers. *Photo Credit: Kilburn Brothers. Courtesy Littleton Historical Society.*

Invented by Oliver Wendell Holmes, a stereoscope was an instrument with two eyepieces through which a pair of photographs of the same scene taken at slightly differing angles was viewed side by side, giving the optical illusion of depth or three dimensions. During this time, stereoscopic viewing of cardboard slides created by the Kilburn Brothers, and their local competitors Weller and Aldrich, became a popular parlor game in homes across the country.

While Edward Kilburn ran the plant in Littleton, Benjamin traveled across the United States and internationally with his camera, shooting scenes and collecting images, aided by hundreds of photographers covering historical events. Naturally, the earliest views focused on the White Mountains, scenes familiar to the Kilburn brothers. Later images featured scenes of New England, New York, Pennsylvania and the Southern and Western United States. Eventually, Ben's travels allowed him to gather images from Cuba, Mexico, Bermuda, England, Scotland, Italy, Germany, France and Scandinavia.

The "first issue" Kilburn Brothers' stereoviews numbering over 200 are recognizable because of government stamps affixed to the back of each card, a federal requirement from 1864 to 1866 to help finance the Civil War. At its peak, the Kilburn factory on Cottage Street in Littleton was thought to house over 100,000 negatives and employed more than one hundred employees who produced approximately 5 million slides yearly.[24]

FIRST TRANSATLANTIC CABLE

A July 1874 artist's engraving in *Harper's Weekly* indicates that there was a large crowd of spectators on hand to witness the landing of the first direct ocean telecommunications cable between Europe and the United States that occurred on July 15, 1874. The cable landed at Straw's Point at Rye Beach, New Hampshire. The cable stretched under the ocean 3,100 nautical miles from the "Drowned Forest" at Rye's Jenness Beach to Balinskelligs Bay, Ireland, touching Halifax, Nova Scotia, on its way. The steamship *Faraday* laid this direct cable with assistance from the ship *Ambassador*.

In 1895, in his article "Gems of the New Hampshire Shore," L.K.H. Lane wrote about the impact of the direct cable: "Previous to the opening of the Direct cable, thirty or forty minutes was considered remarkable time in which to get a reply to a cablegram, but now New York and Boston merchants and bankers in the ordinary course of business obtain replies from their European correspondents in ten minutes."

The huge cable can sometimes be seen at low tide amidst the ancient stumps of the "Drowned Forest" located in a shallow cove south of Odiorne Point. The "Drowned Forest" has been the subject of much scientific study. As early as 1895, scientists believed that this forest provided evidence that the Isles of Shoals were at one time part of the mainland of New Hampshire. Current scientific observation indicates that the roots of the tree stumps, which are only visible at low tide, are embedded in woodland peat, indicating that they were not brought to the shore from elsewhere, but are, in fact, in the same position they were when they were alive. Most of the trees are white pines, with a few hemlocks and maples, and may have been about one hundred years old when they died.

According to geologists, the forest submersion was most likely due to the return of melting glaciers to the sea, seemingly marking the close of the Ice Age. Only the stumps remain, weathered but not dislodged by centuries of pounding tides.[25]

PIONEER GRANITE QUARRIERS BUILD THE LIBRARY OF CONGRESS

Granite was a common building material in New Hampshire since the time of gristmills, as early as 1729. At one time, there were twenty-seven different quarries at Rattlesnake Hill in West Concord, New Hampshire.

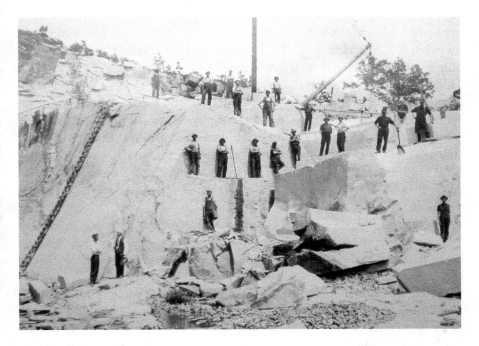

The Swenson Granite Company, circa 1900. John Swenson is second from the left. *Photo Copy: E. W. Whitney III. Courtesy Swenson Granite Company.*

Concord businessman Luther Roby is credited with making known the impeccable qualities of Concord granite quarried at Rattlesnake Hill to people throughout the nation. Concord granite became the standard by which other quarries were judged. It became common knowledge in the industry that the unusual aspect about Concord granite was the fact that it was "perfectly free from those oxides, or other mineral substances, which on exposure to the atmosphere, mar the beauty of much of New England granite."

By 1874, the quarry at Rattlesnake Hill was referred to as "the gold mine of Concord." According to one well-known geologist, Concord granite was referred to as "one of the most important granites of the United States." Roby's quarry operation was the only one referenced in the 1850 census. At the time, Roby employed twenty people. Twenty-five years later, more than five hundred people worked in eleven quarries across the Granite State.

In 1883, Swedish immigrant John Swenson founded the John Swenson Granite Company at Rattlesnake Hill, where it has been in operation by the Swenson family for four generations. The hill is made up of muscovite-biotite granite, valuable for its fine grain, light color, relative lack of

impurities and easy splitting qualities. In 1883, there were fourteen other quarries at Rattlesnake Hill. Today the Swenson Granite Company is the only remaining quarrier of Rattlesnake Hill.

In 1886, Concord granite was selected to build the Library of Congress. New England Granite Company of Hartford, Connecticut, had just acquired a major quarry in Concord, and won the contract. It took three hundred men six years to quarry the necessary granite. During the six-year period, over one thousand men worked in the quarries of Concord, New Hampshire, to supply this one job, splitting and finishing 350,000 cubic feet of granite, an order that exceeded all others in the building trades at the time.

The New England Granite Company was described by one journalist as "the most complete plant in the world for cutting granite." The quarry boasted twelve acres of stonecutting yards. Each of the granite blocks transported from Concord to Washington, D.C., on 2,200 railway cars departed the stonecutting sheds "in absolute readiness for the position which they are to occupy in the edifice. Each one is numbered, and is put in its proper place without being changed in any way after its arrival in Washington." The Library of Congress, begun in 1886 and completed in 1897, was thought to be the largest building in the world at the time.

In 1894, the Swenson Granite Company secured its first major building contract: the First Church of Christ Scientist in Boston. In 1915, when Swenson's three sons—Omar, Guy and John Arthur—joined their father in the business, the family worked on securing several large building contracts. Their best-known building was the Waldorf Astoria Hotel in New York City. Today, fourth-generation brothers Kurt and Kevin Swenson serve as president and vice-president of sales, respectively. Today, a key product is roadside curbing. The Swenson Granite Company supplies over 330,000 linear feet of granite curbing for New England each year.[26]

FIRST MEDICAL X-RAY

In 1895, a German physicist, Wilhem K. Roentgen, wrote an article in the *Sitzungsberichte der Wurzburger Phyzik-medic* entitled "On a New Kind of Rays." He wrote, "It is seen, therefore, that some agent is capable of penetrating black cardboard which is quite opaque to ultraviolet light, sunlight or arc-light. It is therefore of interest to investigate how far other bodies can be penetrated by this same agent."

The January 23, 1896 issue of *Nature* featured a translation of this article by Arthur Stanton. Three weeks later, the February 14 issue of *Science* indicated that three American laboratories were on the same track, the earliest at Dartmouth College. Edwin Brant Frost, Dartmouth professor of astronomy, wrote,

> *Experiments with Roentgen's newly discovered X-Rays have been carried on during the past few days in the Dartmouth physical laboratory by Professor C.F. Emerson and the writer, and some of the preliminary results already obtained may be worth recording...It was possible yesterday to test the method upon a broken arm. After an exposure of 20 minutes the plate on development showed the fracture of the ulna very distinctly.*

The momentous discovery came about because of the interaction between two brothers—Dartmouth astronomy professor Dr. Edwin Brant Frost and Dr. Gilman D. Frost, Dartmouth Medical School professor and director of the Mary Hitchcock Memorial Hospital. The Frosts had come to Hanover

Physics Professor Edwin Frost (left) taking the first X-ray of fourteen-year-old Eddie McCarthy's wrist, with Dr. Gilman Frost and nurse Mrs. Gilman Frost observing. *Photo Credit: H.H.H. Langill. Courtesy Dartmouth Medical School.*

when Edwin was five, when their father, Dr. Carlton P. Frost, accepted a professorship in medicine at Dartmouth. Both brothers eventually became Dartmouth professors. It can be surmised that as of January 22, 1896, when the Frost brothers gathered at the Dartmouth Scientific Association Meeting, Roentgen's work was not yet common knowledge, as it was not included "in the most important events and achievements in each department during the last twelve months." Also at this meeting were Professor of Physics and Dean C.F. Emerson; Physics Assistant F.E. Austin; and photographer H.H.H. Langill. Most likely they learned of Roentgen's discovery four days later when it was highlighted in a front-page article of the *Sun*.

Many years later, E.B. Frost reminisced in the *Dartmouth Alumni Magazine*:

> *During the years 1887–1889 the writer had been assistant to Professor Emerson in the Physical Laboratory on the ground floor of Reed Hall, and had the privilege of using the apparatus there. When the cable hints were received about Roentgen's success, it immediately seemed worthwhile to test the numerous vacuum tubes in our laboratory for their capacity to produce mysterious rays. Our good friend H.H.H. Langill, the local photographer, who was always glad to assist in scientific experiments, took care of the developing and printing of pictures. The results were immediate and startling, particularly since the Roentgen article in* Nature *had not then arrived…None could ever forget the interest felt in watching the development of those first plates on that Saturday evening either January 24 or February 1, 1896, probably the latter.*

Two days later, on February 3, 1896, the opportunity to use X-rays in a practical way presented itself to Dr. Gilman Frost when young Eddy McCarthy of Hanover fell while skating on the Connecticut River. Dr. Gilman Frost brought McCarthy to the physics laboratory in the basement of Reed Hall, where his brother, physics and astronomy Professor Edwin B. Frost, shot the first medical X-ray, discerning the broken ulna in McCarthy's wrist.[27]

CREATIVITY AND CULTURE

New Hampshire's Island Poet: Celia Thaxter

Landing for the first time, the stranger is struck only by the sadness of the place, the vast loneliness; for there are not even trees to whisper with familiar voices—nothing but sky and sea and rocks.

So Celia Laighton Thaxter, New Hampshire's singular island poet, described the Isles of Shoals, where she lived most of her life. Thaxter distilled for us the experience only she could express—the distinct point of view of one who not only grew up on an island, but also lived in a lighthouse, a unique vantage point from which to see the fickle indifference of nature. Thaxter could marvel at the calm sea on a summer's day while never forgetting the blizzard gales that extinguish a stove's fires on a wintry night.

In "Celia Thaxter's Controversy with Nature," Perry D. Westbrook proposes that Thaxter's "rugged realism" puts her among the first of "modern" American writers to view nature as indifferent, even hostile, rather than romantic.

In 1839, when Celia was just four, her father Thomas Laighton, a state senator and prominent Portsmouth businessman, ran for governor and in his chagrin over his defeat sought the appointment to White Island lighthouse, with the idea of moving his wife and three children offshore, never to return to the mainland. While Celia seems to have inherited a sense of independence from her father, it was her mother who set the tone for Celia and her brothers, who were teenagers before they ever crossed the nine miles of ocean that separated them from Portsmouth.

Westbrook wrote, "Judging from the magnificent devotion of her children, the mother must have been a woman of extraordinary resources and depth

of feeling. To her more than any one else belongs undoubtedly the success of the venture. Yet in the nature of things the children were cast upon their own resources; environment and the self were their greatest educators."

Celia had the sea, the seasons, her imagination and keen observation skills. Celia knew the mystery and terror of a winter blizzard and yet sojourned into summer, where she cultivated miniscule gardens in sun-drenched tidal pools. Outwardly, the events of Thaxter's life are rather unremarkable. She lived a few years in Newtonville, Massachusetts, but most of her life on Appledore Island.

While Celia, at age sixteen, fell in love with her tutor Levi Thaxter, eleven years her senior, Levi quickly fell in love with the Shoals and Celia's connection to them. According to Mary Thacher Higginson, who wrote about Celia's life in 1914, Celia's wedding was decided upon, the pastor sent for and the ceremony performed all in one day. Though Celia's marriage to Thaxter was relatively unhappy, serendipitously, it was Thaxter who valued education, encouraged Celia in her writing and introduced this island girl to renowned men and women of prominent literary and artistic circles.

Celia Thaxter is perhaps best known for her passion for flowers. Perhaps as an act of ultimate defiance toward the treeless islands she knew so

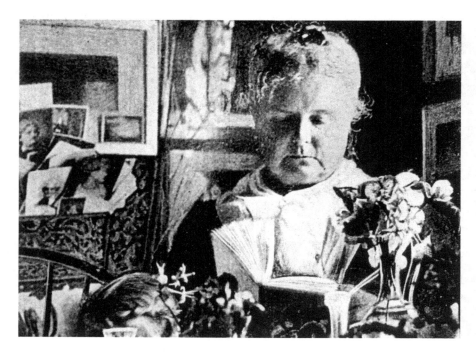

Celia Laighton Thaxter. *Courtesy University Archives, University of New Hampshire.*

well, Thaxter valiantly nurtured flowers—cultivating seedlings in winter; importing toads from the mainland to combat slugs; fighting blight, drought and rain—until she transformed a corner of her bleak island into a radiant panorama of color.

With the same attention and energy she brought to her flowers, Celia offered hospitality to her guests and nurtured creativity in others. Eventually, Celia Thaxter, despite her most unlikely background, became the center of an artistic and literary salon the equal to any in America. Regular visitors to Appledore included J.G. Whittier, Nathaniel Hawthorne, Thomas Bailey Aldrich, Sarah Orne Jewett, musicians Ole Bull and Julius Eichberg and painters William Morris Hunt, J. Appleton Brown, Ross Turner and Childe Hassam.

Celia Thaxter's life was filled with contradiction. She wrote to make a living at a time when few women did. She was a woman who profoundly understood loneliness and, perhaps because of it, nurtured connections with strangers. She personifies the Isles of Shoals that she called home, befriending nature while knowing the price one paid for living a life supremely vulnerable to its passions.[28]

FIRST SCULPTOR TO DESIGN AN AMERICAN COIN

Most people associate the sculptor Augustus Saint-Gaudens, whose home is a national historic site in Cornish, New Hampshire, with his monumental works in public art and portraiture—the Standing Lincoln (seen on page 40), the Shaw Memorial, the Farragut, the Sherman and Adams Memorials. But the genius of Augustus Saint-Gaudens expressed itself on a small scale as well as on a monumental one. Saint-Gaudens was the first sculptor to design an American coin.

Born in 1848 in Dublin, Ireland, to French shoemaker Bernard Paul Ernest Saint-Gaudens and Mary McGuiness, daughter of an Irish plasterer, Augustus Saint-Gaudens was six months old when the family moved to Boston to escape the potato famine. Three weeks later the family settled in New York City. Saint-Gaudens apprenticed for six years with a cameo cutter, while attending Cooper Union art school in the evenings. During this time, Saint-Gaudens developed a deep appreciation for classical numismatic prototypes, illustrated by some of his cameos.

Saint-Gaudens was acting as advisor to the Senate Park Commission in 1901 when he met President Roosevelt. Roosevelt's election to a second term in 1904 spurred him into action regarding gold coinage. General

criticism of the uninspired national coinage in the United States began in about 1890. In January 1905, Roosevelt suggested that Saint-Gaudens try modeling new designs for the gold coins and the one-cent piece.

Saint-Gaudens returned home to Cornish and began preparing sketches. To design coinage, Saint-Gaudens often prepared magnified plaster models about one foot in diameter. According to John H. Dryfhout, former Saint-Gaudens National Historic Site curator, "His [Saint-Gaudens's] first experiments were with various forms of the ten dollar gold piece. A standing eagle which appeared on the reverse of the Inaugural Medal issued in March of 1905, was chosen from among the seventy models he is reported to have prepared." When it came to designing the twenty-dollar gold piece, Saint-Gaudens returned to an image he had made famous just two years earlier—the classical figure of Nike or Victory holding aloft a palm leaf, striding ahead of the equestrian in his Sherman memorial (1903), the famous gilded bronze monument located in the middle of Central Park.

According to Dryfhout, on November 11, 1905, Saint-Gaudens wrote to President Roosevelt and described his design of a winged full-standing figure of Liberty "striding forward as if on a mountain top, holding aloft on one arm a shield bearing the stars and stripes with the word Liberty marked across the field; in the other hand...a flaming torch, the drapery...flowing in the breeze. My idea is to make it a *living* thing typical of progress." Due to Saint-Gaudens's failing health and untimely death and Roosevelt's interest in seeing the gold coins in circulation before Congress convened in January 1908, only the "eagle" and "double eagle" were issued due to the efforts and sheer will of the president.

In 2007, the American Numismatic Society and the Saint-Gaudens National Historic Site combined efforts to produce an exhibit at the Federal Reserve Bank of New York to pay tribute to Saint-Gaudens. Held September 20, 2007, to May 15, 2008, the exhibit was entitled "Theodore Roosevelt, Augustus Saint-Gaudens and America's most beautiful coin." According to Saint-Gaudens National Historic Site Curator Henry Duffy, the U.S. Mint has plans to reissue the Saint-Gaudens high relief twenty-dollar gold coin.

Augustus Saint-Gaudens saw the proofs of his "most beautiful coin," but died before it was issued. Still, his legacy in coinage sits in our pockets today through the evidence left by his students—James Earle Fraser's buffalo nickel; Adolf Weinman's Mercury dime and walking Liberty half dollar; and John Flanagan's Washington quarter, all of which are still circulating today.[29]

The "Lady Victory" side of the super high–relief twenty-dollar gold coin designed by Augustus Saint-Gaudens in 1907. *Courtesy Augustus Saint-Gaudens National Historic Site.*

The "Double Eagle" side of the super high–relief twenty-dollar gold coin designed by Augustus Saint-Gaudens in 1907. *Courtesy Augustus Saint-Gaudens National Historic Site.*

First and Largest Artist Colony in the Nation

In 1896, five years after their first visit to Peterborough, pianist Marian Nevins MacDowell and her husband, celebrated American composer Edward MacDowell, took a train from Boston to Peterborough and purchased an abandoned seventy-five-acre hillside farm owned by Austin Partridge for $1,500. The MacDowells returned every summer to Hillcrest until the composer died in 1908.

In 1906, Edward MacDowell, fatally ill, voiced his dream to create an American version of the American Academy in Rome, which had been founded in 1894 by the renowned architect Charles Follen McKim, a friend of MacDowell. The composer's original intention for the colony was that it focus not only on providing quiet workspace for artists in all media, but also creating and encouraging means for their interaction.

MacDowell wrote, "For years, it has been my dream that the Arts of Architecture, Painting, Sculpture, and Music should come into such close contact that each and all should gain from this mutual companionship. That students in all these Arts should come together under the same roof and amid such marvelous surroundings seems almost too good to be true."

To embody MacDowell's idea of the "affiliated arts," a few distinguished artists, including Sarah Bernhardt, Daniel Chester French, Augustus Saint-Gaudens and Charles McKim, helped form the New York MacDowell Club. In 1907, upon the request of Marian MacDowell, the MacDowell Association was incorporated as a subsidiary of the New York MacDowell Club with the mission of providing this kind of arts community experience in Peterborough. Marian MacDowell deeded the Hillcrest property, then consisting of two hundred acres and three houses, to the association.

When MacDowell had first fallen ill in 1904, the Mendelssohn Glee Club of New York had organized a nationwide appeal for medical expenses, raising $40,000. Among the drive's sponsors were Grover Cleveland, Andrew Carnegie and J. Pierpont Morgan. Upon the composer's death, Marian MacDowell requested that the funds be given to the MacDowell Association.

Today the MacDowell Colony sits on 450 acres of woodlands and fields with spaces to host thirty-one artists at a time year-round. Since sculptor Helen Mears and writer Mary Mears became the first MacDowell Fellows, the internationally renowned MacDowell Colony has been a driving force behind the creativity and innovation that have fostered more than fifty Pulitzer Prizes, sixty Prix DeRome recipients and seven MacArthur Foundation fellows.[30]

Helen and Mary Mears, first MacDowell Colony Fellows, on the porch of New Hampshire Studio, built in 1909, formerly the Peterborough Studio. *Courtesy MacDowell Colony*.

FIRST STATE TO SUPPORT THE ARTS AND FIRST CRAFTS FAIR IN THE NATION

In the mid-1920s, just about the same time that Mrs. J. Randolph Coolidge established the Sandwich Home Industries by opening a tearoom and a cooperative crafts shop that offered crafts classes in Center Sandwich, A. Cooper Ballentine began teaching craft classes in Wolfeboro, sponsored by the rotary club. Their simultaneous motivations to create, teach and sell handcrafts came together when Ballentine took his group to Center Sandwich to discuss a cooperative effort. The ripple effects of that first conversation formed the oldest statewide crafts organization in the country and the first state to obtain government support for the arts.

Coolidge and Ballentine formed a committee for the promotion of the handicraft movement, and began devising a statewide plan for training craftspeople. They called upon experts for help, including Royal Bailey Farnum, director of the Rhode Island School of Design and the former head of the Massachusetts College of Art; and Allen Eaton, an affiliate

of the Russell Sage Foundation already at work on helping the Southern Highland Handicraft Guild.

Mr. Farnum said, "The moment ideals of art are relinquished for the sake of quantity production or seemingly more rapid sales danger lies ahead and the strength of the League's work will begin to weaken... History has shown again and again that the state and the nation which supports its art lives on forever."

In 1931, after many conferences and meetings in search of clear direction, this committee asked John Winant, governor of New Hampshire, for state support for the arts, which he granted by establishing and funding the New Hampshire Commission of Arts and Crafts, thus making the Granite State the first state in the United States to officially support the arts.

The original seven-member commission included Dean Case of the University of New Hampshire; James Pringle, commissioner of education; Philip Ayres, first forester for the Society for the Protection of New Hampshire Forests; William Barron, owner of the Crawford House; Ballentine; Coolidge; and Margaret Whipple of Bristol. This cooperative group submitted its first report in September 1931.

Certain philosophical tenants in that first report still reflect the goals of the League:

> *To raise New Hampshire crafts and craftsmanship to the highest authentic level. To provide gainful occupation for men, women, and youth of the state in home industries, native handcrafts, and the arts. To promote this philosophy adequately...through the development of confidence and State pride in local ability and creative power.*

This report recommended the formation of the League of New Hampshire Craftsmen, which became official in February 1932.

In 1933, while League headquarters in Concord consisted of "two small rooms, the director and his assistant as staff members, and a warehouse that was the back of the director's car," as League historian Betty Steele wrote, local groups were assimilating their own version of a crafts education program and, in some cases, crafts shops. By 1933, Concord, Conway, Meredith and Wolfeboro Home Industries, as they were named then, had formed. By 1935, there were forty-seven League crafts groups, with twenty-three groups operating small shops—often in a front room and a porch or barn for display.

In 1934, the League held the first Craftsmen's Fair, hosted by the Crawford House in Crawford Notch, where craftspeople set up their wares in a barn usually used to house old stagecoaches. Horse stalls provided exhibit space.

The League of New Hampshire Craftsmen Annual Craftsmen's Fair, circa 1970. *Courtesy League of New Hampshire Craftsmen.*

The first fair exceeded expectations, netting $2,698, and became an annual event. The next year, the fair moved to Hancock Town Hall and church vestry and featured crafts demonstrations in horse stalls and, after that, to a different town each year until 1948, when it settled for a time in Gilford. In 1964, the Annual Craftsmen's Fair moved to Mount Sunapee State Park, where it continues today annually during the first ten days of August.

In 1938, David Campbell became director of the League, a position he held for a quarter century. A visionary about understanding the rising importance of designer-craftsmen, Campbell developed a business system and raised standards of artistic excellence by convincing professional craftspeople from around the nation to relocate to New Hampshire. In the fall of 1940, Campbell was responsible for encouraging potters Edwin and Mary Scheier to move from Virginia. Other professionals who relocated at Campbell's urging included metalsmith Jess Blackstone; enamellist

Karl Drerup; potters Vivika and Otto Heino; jeweler George Salo; potter Gerry Williams; sculptor and Fulbright fellow Winslow Eaves; woodworker Gordon Keeler; cabinetmaker Alejandro de la Cruz; weaver Lilly Hoffman; and enamellist Joe Trippetti. New Hampshire's link to the national crafts scene grew with the appointment of Campbell to the top position at the American Crafts Council and architect for the Museum of Contemporary Crafts, thereby establishing the national reputation of New Hampshire as a pioneering state in the field of arts and crafts.

A portrait of Mrs. Coolidge hangs in a prominent spot at the Museum of New Hampshire History, paying tribute to the early arts and crafts heritage of the Granite State.[31]

OLDEST PROFESSIONAL SUMMER THEATER IN THE NATION

Theater became a part of Francis Cleveland's life almost through osmosis. As the youngest child of President Grover Cleveland, he no doubt heard many stories about one of his father's closest friends, celebrated American

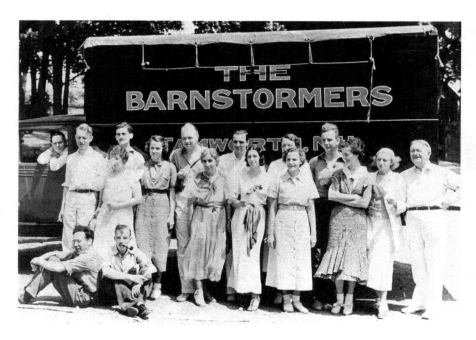

The Barnstormers' early troupe, Tamworth, circa 1945. *Courtesy the Barnstormers.*

actor Joseph Jefferson, though he was too young to remember Jefferson. Jefferson lived next door to the Clevelands in the resort community of Bourne on Buzzards Bay in Massachusetts, a getaway vacation spot chosen by the president to escape the constrictions of political life.

Personally inspired throughout his life by First Lady Frances Folsum Cleveland, who loved the theater, Francis Cleveland pursued his passion for the theater in New York, appearing in the original Broadway productions of *Our Town* and *Dead End*.

While simultaneously pursuing his professional acting career in Boston and New York, Francis Cleveland, along with his wife Alice and their friend Edward P. Goodnow, founded the Barnstormers Theater in Tamworth in June 1931. The acting troupe consisted of young theater graduates from Harvard, Wellesley, Radcliffe and Amherst, among other colleges. Goodnow was a graduate of Harvard and George Pierce Baker's 47 workshop and became the troupe's first director.

Though the summer residents of New Hampshire provided an extensive audience from which to draw, Cleveland was still suspect that he could not

Blind Alley, 1936 production. *From left to right*: Francis Cleveland, Muriel Williams and Lester Damon pointing the gun. *Courtesy the Barnstormers.*

get others to drive to Tamworth to see a play. Hence, the young acting troupe "barnstormed" around central New England, sometimes traveling as far as eighty miles. The Barnstormers performed in Wolfeboro, Franconia, Conway, Holderness, Harrison and even Poland Springs, Maine. The troupe caravanned in open touring cars, transporting sets in an old truck.

The Barnstormers started productions in Tamworth Gardens, a large building behind the Tamworth Inn, used at one time for boxing exhibitions and still used by the troupe today for rehearsal space. In 1935, Francis and Alice Cleveland purchased Kimball's Store, across the street from the inn, and renovated it into a theater. Barnstorming to different towns ceased with World War II and has since never resumed, with all subsequent performances held in the original theater, which was unchanged until 1997, when a capital campaign updated and winterized the original building.

Almost from its beginnings, the Barnstormers have been associated with Equity, the professional actors' union, and was recognized as the oldest Equity theater in the country under the same direction, until Francis Cleveland's death in 1995. Exhaustive research on the topic since has revealed that the Barnstormers are still the "oldest professional summer theater in the country."[32]

WAR MEMORIAL TO WOMEN: CATHEDRAL OF THE PINES

As pioneers, nurses, nuns, entertainers, war correspondents, riveters, soldiers on land, sea or in the air—women have always worn many hats and wartime was no different. When Dr. Douglas Sloane originally built the Altar of the Nation at the Cathedral of the Pines, he always considered that it represented both men and women who had sacrificed their lives for their country. However, he had always hoped to honor women specifically in some way.

One day a woman visited the Cathedral of the Pines and talked with Dr. Sloane. The next day she sent a check for $460,000. As a result, in 1963, Sloane broke ground to build the fifty-five-foot tall Memorial Bell Tower at Cathedral of the Pines to honor all American women who had lost their lives in service of their country. Like the Altar of the Nation, the pillars of the bell tower are built from crops of discarded fieldstones, the premise being that each rock is a reminder of the daily heroic struggles of the early settlers to find the freedom to live and worship in their own way. Sloane wrote, "These stones, bound together in the Memorial Bell Tower symbolize the strength and unity of a grateful nation."

Dedication of the Women's Memorial Bell Tower, "A National Tribute to All American Women Who Sacrificed Their Lives in the Wars of Our Country," May 28, 1967, Cathedral of the Pines. *Courtesy Cathedral of the Pines.*

Norman Rockwell in his studio designing Tablet No. 1, "Girls of Combat Forces." *Courtesy Cathedral of the Pines.*

To pay tribute to the different facets of service given by women who had sacrificed their lives for others, Sloane wanted four different bronze reliefs designed to hang on each side of the bell tower. Sloane chose Norman Rockwell to design these reliefs because he was the most celebrated illustrator of the time. His son Peter Rockwell executed each relief.

Tablet number one, facing west, "Girls of the Combat Forces," features women of the army, navy, marine corps, air corps and coast guard. Tablet number two, facing east, features a Sister of Charity nun who tended the dying in the War of 1812 and the War Between the States; a Salvation Army "Lassie" who served the troops in canteen work; a USO entertainer; a war correspondent; and a riveter, representing the women who replaced the men in the shipyards, munitions and aviation plants, as well as in shops, factories and on the farms. Tablet number three, facing north, pays tribute to Clara Barton, founder of the American Red Cross, and all the female nurses serving the combat forces. Tablet number four, facing south, portrays the pioneer woman defending her children and homestead as her husband went off to war.

In addition, Sloane designed a "Tree of Life" sculpture that sits in the archway of the bell tower enclosed by wrought-iron gates. The inspiration for the sculpture made by Jarl Hesselbarth of Hyde Park, New York, is from Revelations 22:1, 2: "Tree of Life, which bears twelve manner of fruits, and yielded her fruit every month; and the leaves of the tree were for the healing of the nations." Each branch bears a different fruit— breadfruit, pear, fig, peach, olive, orange, avocado, apple, lemon, cherry, pomegranate and plum. The trunk of the tree emphasizes a woman's backbone, symbolizing her stamina, determination and courage as the mother of men.

On May 28, 1967, the Women's Memorial Bell Tower was officially dedicated. At the time, the governor from every state and territory in the United States had contributed to the building fund.

The anonymous author of the bell tower dedication booklet said it best:

> *Henry Ward Beecher said that if he were invited to give an oration on July 4th he would celebrate the virtues of the fore-mothers instead of the fore-fathers. The latter, he said, had monopolized all the glory although their mothers, wives, and daughters had induced quite as much and had evinced at least equal piety and heroism in subduing the wilderness and securing our national independence.*[33]

Robert Frost. *Courtesy the Lotte Jacobi Collection, University of New Hampshire.*

MOST CELEBRATED POET: ROBERT FROST

Robert Frost once said, "Literature begins with geography." The words could not be truer for Frost and his relationship to New Hampshire. He lived in the Granite State during two of the most productive times in his life and his poetry is forever entwined with the landscape surrounding his Derry farm and his hillside house in Franconia.

84

Frost was born in San Francisco, California, to Robert Lee Frost, a journalist, and Isabelle Moodie, a teacher. In 1885, when his father died of tuberculosis, to honor his father's wishes to be buried where he was born, his mother took a train with Robert and his sister Jeanie to Lawrence, Massachusetts. They relocated there, as Frost's paternal grandfather William Prescott Frost would make sure his grandson had good schooling.

As his parents were teachers, Frost was familiar with the world of books, gravitating to Robert Burns, William Wordsworth and Shakespeare. At Lawrence High School, Frost excelled in history, botany, Latin and Greek and in 1890 had a few poems published in the school newspaper. He graduated at the head of his class.

Despite his grandfather's gift of a college education, Frost entered Dartmouth in 1892 but left a few months later, preferring the craft of a tradesman to a college campus. He took a series of odd jobs, including teaching and working in a mill, but continued to write poetry. In 1894, Frost sold his first poem, "My Butterfly: An Elegy," for a stipend of fifteen dollars to the New York magazine *Independent*. In 1895, Frost married his high school sweetheart and co-valedictorian, Elinor Miriam White.

In 1900, Robert Frost moved his family to a farm in Derry, New Hampshire, that had been bought by his grandfather, where he grew apples, raised chickens and continued to write and suffer consistent rejection. The *Atlantic Monthly* responded to one submission: "We regret that the *Atlantic Monthly* has no place for your vigorous verse."

In 1912, after twenty years of rejections, Frost sold the Derry farm and moved his wife and four young children to a cottage in Beaconsfield, England, outside of London. The magical change of scene worked. In 1913, David Nutt, a small London printer, published *A Boy's Will*, Frost's first collection of poetry. Frost met fellow poets Edward Thomas and Ezra Pound, who helped promote his work. *North of Boston* followed in 1914. In 1915, American publisher Henry Holt printed the first collection. When World War I started, the Frosts moved back home and bought a farm in Franconia. When the *Atlantic Monthly* came calling this time, Frost submitted the very same poems that had been rejected years earlier. *Mountain Interval* (1916) included many poems written in Franconia.

In 1923, *New Hampshire*, Frost's fourth collection of poems, won the Pulitzer Prize. Frost won three other Pulitzers for *Collected Poems* (1930); *A Further Range* (1936); and *A Witness Tree* (1942). Frost was the first poet to participate in a presidential inauguration, for President John Kennedy in 1961. When wind and sun hampered his reading of his new poem "The Preface," Frost recited an old one—"The Gift Outright."

It is often difficult to imagine that a poet as celebrated as Frost knew pain, depression and self-doubt. In fact, throughout his life Robert Frost experienced great personal loss. The year he moved to Derry, he lost his son Elliot of cholera and his mother to cancer. In 1907, he lost a daughter Elinor Bettina in birth. In 1928, he lost his sister Jeanie. Between 1934 and 1940, he lost his daughter Marjorie in childbirth, his wife Elinor of a heart attack and his son Carol, who committed suicide.

At his death on January 29, 1963, Frost had become so popular, it might be argued that he had become a kind of unofficial national poet laureate. Perhaps he was such an exquisite poet because he reveled in contradiction—in nature, in mankind, in life itself at its most mundane and joyous—but also maybe because he was an enigma, too. In his 1999 biography, Jay Parini wrote of Frost:

> He was a loner who liked company; a poet of isolation who sought a mass audience; a rebel who sought to fit in. Although a family man to the core, he frequently felt alienated from his wife and children and withdrew into reveries. While preferring to stay at home, he traveled more than any poet of his generation to give lectures and readings, even though he remained terrified of public speaking to the end.[34]

US FIRST: Pioneering Science and Technology Education

In 1989, Dean Kamen of Bedford, New Hampshire, an inventor and entrepreneur driven by his passion to inspire the youth of America about science and technology, founded US FIRST—United States For Inspiration and Recognition of Science and Technology.

Out of his own frustration that teachers could not answer his questions as a student, young Kamen began reading the original works of Archimedes, Galileo, Newton and Einstein. In his first job after high school with an audiovisual company, Kamen designed a small control box that his employer bought for $2,000. During his first year at Worcester Polytechnic Institute, Kamen began making his new product in the basement of his parents' home, selling $60,000 worth within a year.

When Kamen observed the problem nurses had in the dispensation of regular amounts of medicine, he invented the first portable drug-infusion pump. News of his invention in the *New England Journal of Medicine* provided Kamen with an order for one hundred pumps from the National Institutes

of Health. Kamen began his own company, Auto-Syringe, in his parents' basement. In 1975, at age twenty-four, Kamen expanded his business to an industrial facility and hired an engineering staff. A dropout from Worcester Polytechnic Institute, Kamen currently holds more than forty patents relating to medical devices, climate control systems and helicopter design.

Consumed by the desire to fight "techno-illiteracy," Kamen convinced corporate giants like Procter & Gamble, Motorola, Boeing, Ford, Honeywell, Ingersoll-Rand and Xerox to donate money and engineers to work with high school youth.

As Steve Kemper described in *Smithsonian Magazine*, Kamen created US FIRST "to persuade kids that engineering and technology are far more exciting than slam dunks, Nintendo, and MTV. And its method of persuasion is a high-tech sporting event, created by Massachusetts Institute of Technology professor Woodie Flowers, which pits gladiator robots designed by teams of high school students and corporate engineers."

In 1992, twenty-eight teams competed in Kamen's first US FIRST competition. By 1994, the field of participants had risen to forty-three teams from fifteen states and Jamaica who came to New Hampshire to compete. Two hundred teams competed in the 1998 competition at Walt Disney World's Epcot in Orlando, Florida. In 2007, FIRST held thirty-seven competitions. Kamen remains the force behind FIRST, providing more than one thousand high schools with tools to learn valuable engineering skills.

In June 1998, Kamen created FIRST PLACE, a science and technology–based center in Manchester, New Hampshire. He partnered with LEGO to develop the FIRST LEGO League Robotics Competition, and worked with Walt Disney World to develop a FIRST Pavilion at Disney's Epcot Center devoted to inspiring youth toward careers in science and technology.

In addition to his passion for science and technology education, Dean Kamen continues to follow his own visionary path. He is best known for inventing the iBOT wheelchair mobility system and the Segway, a self-balancing human transporter.

Most recently, he has invented a device about the size of a washing machine that has the potential to transform the developing world. An estimated 1.1 billion people in the world do not have access to clean drinking water, and an estimated 1.6 billion do not have electricity. Kamen has invented a device that purifies water—any water—while producing

electricity. "Eighty percent of all diseases you could name would be wiped out if you just gave people clean water," says Kamen. "The water purifier makes one thousand liters of clean water a day, and we don't care what goes into it. And the power generator makes a kilowatt off anything that burns." The plentiful fuel? Cow dung.

To honor one of New Hampshire's most prolific inventors, the Museum of New Hampshire History displays one of Dean Kamen's C1 Segway Personal Transporters named "Ginger," a gift donated by Kamen in 2008.[35]

SEASONS:
WORK AND RECREATION

The Oldest Summer Resort in America

Summer is fleeting in New Hampshire, and so was the earliest summer resort in the nation. At its peak, the country estate and plantation of Royal Governor John Wentworth was one of the largest, most imposing homes in colonial New England. The third Wentworth to govern New Hampshire, John Wentworth was the last colonial governor of New Hampshire. After graduating from Harvard, he went to work for his father. In October 1759, John Wentworth became a proprietor of the township of Wolfeboro, which was then still very much frontier, so much so that, in fact, in April 1762, Wentworth was named to a committee formed to promote the settlement of the Wolfeboro area. In 1763, Wentworth returned to England to study law for four years. On August 11, 1766, King George II appointed Wentworth governor of New Hampshire and "surveyor of the King's Woods in North America." During this time, certain tall pines that grew in a region called King's Woods were reserved for use as masts for the Royal Navy ships. The name Kingswood in the Wolfeboro area came from this context.

Wentworth created new townships inland, encouraging settlers to move away from the densely populated coast by selling lots to them, but always reserving land for himself. In 1767, just after visiting the Wentworth ancestral home in Yorkshire, England, Wentworth seems to have gotten inspiration to build a mansion inland, and began acquiring lots on the northern edge of what is now Lake Winnipesaukee. Here, from 1768 to 1775, he created a county seat of the government, claiming 3,592 acres, but his estate actually measured approximately 6,000 acres—one of the largest plantations ever created in New England. By building a country home fifty miles from the bustling capital of Portsmouth, and living at his plantation in the summer months, Wentworth aimed at moving colonization inland. Consequently, Wolfeboro became "the oldest summer resort in America."

The governor's own writings suggest the magnitude of his summer estate. Approximately 150 men worked on the plantation during the first two years, clearing several hundreds of acres, planting fields and two large apple orchards and creating a six-hundred-acre park stocked with deer and moose. Workers cleared a landing on the edge of the lake where boats and gondolas arrived laden with cattle and produce, thereby beginning the first navigation on Lake Winnipesaukee. The governor maintained a two-masted sloop *Rockingham*, named for his patron, Lord Rockingham.

The Wentworth mansion was even more impressive, as it was the largest dwelling of its day in New Hampshire. The two-storied, gambrel-roofed mansion designed by Peter Harrison measured one hundred feet by forty feet and had a twelve-foot-wide hall extending the length of the building. Additional buildings included a gardener's house, a one-hundred-foot barn, two large stable and coach houses, a dairy house, smokehouses, an ashes house, a carpenter's shop, a blacksmith's shop, a cabinetmaker's shop, one or two sawmills, a gristmill and other houses for workers.

In June 1775, Wentworth fled Portsmouth with his wife and son to Fort William and Mary, where he stayed for a time. On February 7, 1778, when he saw that winds of change no longer welcomed his rule, Wentworth departed for Canada, and was named lieutenant governor of Nova Scotia, where he stayed—and built a third mansion. He died in 1820.

The Wentworth-Coolidge Mansion located on Little Harbor in Portsmouth is open seasonally. *Photo Credit: E.W. Whitney III.*

Though virtually nothing remains of the Wolfeboro Wentworth Mansion, the Wentworth family legacy lives on in the Wentworth-Coolidge Mansion that still stands on the edge of Little Harbor in Portsmouth. The mansion was built in the mid-eighteenth century by Royal Governor Benning Wentworth, the longest-serving royal governor in British America, who governed New Hampshire from 1741 to 1767, and was eventually succeeded by his nephew John Wentworth, New Hampshire's last royal governor. Composed of several preexisting buildings cobbled together, the sprawling yellow house features three distinct wings, each with an entrance and staircase: a servants' wing, a family wing, and a state wing. In 1886, J. Templeton Coolidge of Boston bought the house as a summer home. A Harvard graduate, amateur artist and patron of the arts in Boston, Coolidge and his friends gathered and formed a creative summer arts colony at Little Harbor. The Wentworth-Coolidge Mansion is open for tours seasonally.[36]

OLDEST SKI CLUB: PIONEERS IN SKI JUMPING

Skiing came to New Hampshire through the Scandinavian immigrants who came to the Eastern United States in the 1840s and 1850s, primarily recruited to work on laying the track for the Atlantic and St. Lawrence Railroad from Portland to Montreal. A logging company, Winslow Company of Berlin, convinced some of these immigrants to settle in Berlin and take up logging. By the 1870s, as many as thirty families of Scandinavian descent are believed to have made their homes in what became known as Norway Village just outside of Berlin.

The Norwegians brought with them a five-thousand-year-old winter culture that encompassed all kinds of winter sporting activities. As early as 1872, Scandinavians met together regularly for sliding and leaping off of homemade ski jumps on Sunday afternoons. Unofficial historians claim that in February 1872, they formed a "skiklubben"—a ski club. Legend was that the club's founding date was put on the old Brown Company sawmill chimney, but no photographs of the chimney exist.

The club was later renamed the Berlin Mills Ski Club. Each member paid his "dues" thorough labor, contributing to the community by building a hut, making or repairing ski poles or clearing trails year-round. When Fridtjof Nansen skied across Greenland, the club was renamed in his honor—the Fridtjof Nansen Ski Club, shortened in 1912 to the Nansen Ski Club.

Alf Halvorson of Berlin first became interested in the Nansen Ski Club at the age of eighteen and eventually became an early president. On January

15, 1882, he recorded the first official record about the formation of the ski club.

Early skiing primarily involved ski jumping and, occasionally, cross-country skiing. Ski jumping unofficially began in 1906 in Norway Village but moved to town when the Nansen Ski Club built a ski jump in Paine's Meadow, Berlin, and Berlin Winter Carnival jumping began. In 1921, the first major ski jump was built 65 feet high, with a 170-foot run out that was later enlarged in 1927.

In the 1920s, Berlin ski jumpers competed in meets at other New England hills including Salisbury, Connecticut, and Brattleboro, Vermont, creating

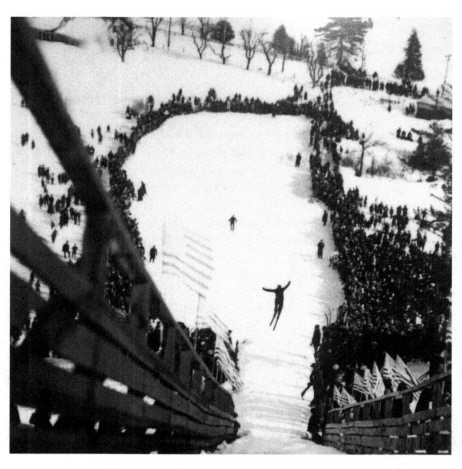

In 1936, the City of Berlin began building the Nansen Jump—171 feet high with a 312-foot outrun—completed in time for the 1938 Olympic trials held in Berlin. *Photo Copy: Mark R. Ducharme. Courtesy Northern Forest Heritage Park.*

a sense of camaraderie that sparked the idea of forming a ski organization in the East. Consequently, the Nansen Ski Club joined six other clubs and formed the United States Eastern Amateur Ski Association.

In 1936, the city of Berlin and the National Youth Administration began construction of the Nansen Jump on a hillside north of Berlin—a 171-foot-high ski jump with a 312-foot outrun—completed in time for the Olympic trials held in Berlin in 1938. The Berlin Ski Jump was the highest ski jump in the United States and drew thousands of spectators to view winter carnival competitions. During the heydays of ski jumping, most New Hampshire colleges sponsored jumping teams. But problems with injury and liability caused a decline and eventual discontinuation of the sport and the closure of jumps such as the one in Berlin—the skeleton of which is still visible off Route 16.[37]

LARGEST ICEHOUSE IN THE WORLD

In 1890, the Fresh Pond Ice Company of Somerville, Massachusetts, moved its operations to the clear, spring-fed waters on the southern edge of Lake Muscatanipus, now known as Lake Potanipo, in Brookline, New Hampshire.

In the first phase of construction, the building consisted of nine icehouses all covered by one roof measuring 245 feet by 180 feet, and including an office, horse barn and an equipment building for a total area of 44,100 square feet. These first houses had the combined capacity of storing 60,000 tons of ice. Four houses were added, expanding capacity to 80,000 tons.

Work in the icehouse began at 2:00 a.m., when boys on horses scraped snow off the ice. Then men and horse teams did the "grooving and cutting" of sixteen-foot square blocks called "floats." The men guided the floats along canals in the lake to a pier where others cut the blocks into forty-four-inch blocks that were then placed on a continuous chain moving along the front of the icehouses. Wingmen with ice hooks grabbed the blocks and moved them to other wingmen who stacked the ice blocks in rows. All the ice harvested was stored under the eaves of this vast building with sawdust and hay added for insulation.

In the heat of summer, thirty to forty railroad cars left Brookline every day, each loaded with forty tons of ice. Virtually all the ice blocks were shipped via the Boston and Maine Railroad to Cambridge and Boston.

Each winter, the icehouse brought in hundreds of workers of all nationalities, nearly doubling the Brookline population. While only twenty

to thirty men worked year-round, the company provided a bunkhouse for three hundred workers. Wages were four to five dollars a day.

Even in its day, the icehouse was considered so unusual that in the late 1930s, *Pathe News* came to Brookline to film the massive building and its ice harvesting operation for a newsreel that was later viewed in theaters across the United States. With the advent of artificial refrigeration in the 1930s, the Fresh Pond Ice Company shipped its last load of ice in 1931.

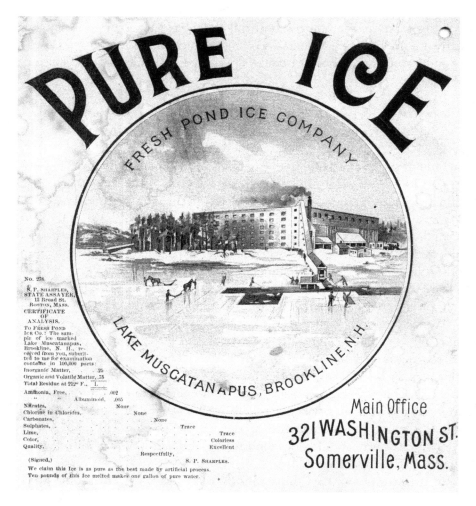

Advertisement for the Fresh Pond Ice Company, Brookline, New Hampshire, circa 1900. *Courtesy Brookline Historical Society.*

On March 21, 1935, fire destroyed the huge facility that had once housed more than three hundred men and 100,000 tons of ice—often referred to then as "Yankee Gold." Lake Potanipo, closed for thirty-three years because of the ice business, was once again opened to fishermen.[38]

Pioneers in Ski Instruction

Sometimes it takes an outsider to see things differently. Skiing has been around for thousands of years as a practical means of transportation in winter climes. But how did skiing become an American sport? According to New England Ski Museum Director Jeff Leigh, the underlying cause may not be what one normally thinks. "The Brits did it," said Leigh in a recent interview. When British tourists came to Austria and Germany, they naturally became intrigued by the recreation and culture of skiing. What came naturally as an instinctive mode of transportation to the Germans and Austrians attracted the British, who saw it as sport and began asking for lessons. In this way, British tourists helped Germans and Austrians realize that there was a livelihood in teaching skiing to those who considered it sport.

In New England at the time of World War I, skiing had become a central part of winter activities. In 1909, Fred Harris founded the Dartmouth Outing Club. In 1911, Dartmouth hosted its first winter carnival. In 1913, Harris and other DOC members skied up the Mount Washington carriage road. As skiing became a sport, collegiate competition followed. As early as 1922, Dartmouth began hiring European ski coaches. In 1923, the Dartmouth Outing Club hired Hungarian World War I Austrian ski trooper Colonel Anton Diettrich as a ski instructor and coach.

The panorama of the White Mountains unfolds at Sugar Hill bordering Franconia. Peckett's-on-Sugar Hill, a rambling white farmhouse, had become known as a winter hideaway and gathering place for the affluent and powerful. In 1928, Katharine Peckett, daughter of the owner, was on Christmas holiday skiing in Engelberg, Switzerland, and returned home impressed by the ski school operation there and convinced her father to open a ski school at Peckett's to increase winter revenue. Peckett's had opened yearly in winter since 1900 for tobogganing, skating, snowshoeing and casual skiing. In the spring of 1929, Kate Peckett had a side hill cleared and the next winter opened the first resort ski school in the country.

In 1930, when German-born Otto Schniebs came to Hanover to become the fourth, and first successful, Dartmouth College Ski Team Coach, he

brought with him great enthusiasm for a new ski technique—the "Arlberg" skiing method, named for the part of Austria where Hannes Schneider developed and championed a crouched skiing style incorporating lift and swing methods to master steep hills. Schneider, former head ski instructor for the Austrian army, became internationally renowned as "skimeister of the world." About this time, Schniebs, an avid disciple of Schneider, gave lessons in this new technique to clubs like the Appalachian Mountain Club.

Schneider challenged the old Norwegian tradition of skiing undulating hills with a graceful telemark style and upright stance and developed a disciplined Arlberg technique, enabling skiers to maneuver steep mountains in relative safety. "I will put speed into everyone's skiing," Schneider said. "It is speed that is the lure, not the touring."

The first two instructors at Peckett's were German, one of whom was Herman Gladfelder. When Kate Peckett met Austrian skier "Sig" Buchmayr in New York City, she persuaded him to come to Sugar Hill as her guest that first year. During the 1930–31 season, Duke Dimitre von Leuchtenburg was the sports director at Peckett's.

Early in 1931, Buchmayr joined von Leuchtenburg as ski instructor, then became director and stayed until Peckett's closed for the winters in 1939. The first ski classes began with exercises on the huge lawn in front of the inn and then moved on to the cleared slope, where instructors taught fundamentals of the Arlberg technique In 1935, Kate Peckett again visited Europe and observed the Hannes Schneider Ski School in St. Anton, Austria. In December 1936, Carroll Reed, a noted skier who had broken his back skiing and would never ski again, nevertheless remained true to his sport and founded the Eastern Slope Ski School in Jackson—the first public ski school in North America—hiring Austrian Benno Rybzka, a Hannes Schneider instructor. In spite of a nearly snowless winter during the 1936–37 season, Reed reported that six thousand lessons were given!

In January 1937, Harvey Dow Gibson, a North Conway native who had become a successful New York City banker, returned home, bought Lookout Mountain and renamed it Mount Cranmore. With an eye toward development and a personal incentive to help build the economy of his hometown, Gibson bought the Randall Hotel and renovated it into the Eastern Slope Inn.

As Gibson was the president of the Manufacturers Trust Company, he was the fiscal agent for Germany in the United States. In that capacity, Gibson arranged for the release of Schneider from a Nazi concentration camp. On February 11, 1939, Schneider and his wife Ludwina and children Herbert

Calisthenics on skis were a trademark of Peckett's ski instruction. *Courtesy New England Ski Museum Collection.*

and Herta arrived in North Conway and Schneider became director of the Eastern Slope Ski School.

Pioneering ski instruction in New Hampshire also included the first ski book and the first ski film. John McCrillis, a 1919 Dartmouth graduate and member of the Dartmouth Outing Club and the Dartmouth ski team, was an avid proponent of Schneider's Arlberg technique. McCrillis teamed up with Otto Schneibs and coauthored *Modern Ski Technique,* a book initially serialized in the *Dartmouth Alumni Magazine* in the December 1931 and January and February 1932 issues. By November 1937, the book, published by Stephen Daye Press, was in its eighth printing. McCrillis and Schneibs also created the first American ski film, which McCrillis showed at the National Ski Association meeting in Chicago in December 1932. According to McCrillis, the film, which is still available at the New England Ski Museum at Cannon Mountain, helped influence the National Ski Association to promote downhill and slalom skiing as competitive sports.[39]

PIONEERS IN SKI RACING

The Hannes Schneider Arlberg ski technique forever transformed skiing from a pastoral, graceful experience into a sport of speed. Competition was not far behind.

Tuckerman's Ravine is located on the eastern side just down from the summit of Mount Washington. Tuckerman's bowl shape means that it is a

repository for windblown snow from throughout the mountain range, which collects and stays through spring and part of summer. Those who wish to ski the ravine must hike up the mountain from Pinkham Notch. It is New Hampshire's most famous ski hill, known for its spectacular scenery, deep snow and treacherous terrain.

Joe Dodge, the legendary caretaker of the AMC lodges at Pinkham Notch, was a model outdoorsman who developed the AMC hut system into a year-round recreational mecca and served as ambassador for thousands of spring skiers who made their way to New Hampshire to test their mettle on the infamous headwall. According to New England Ski Museum Director Jeff Leich, Tuckerman's may be the birthplace of extreme skiing. One aspect of extreme skiing is "heliskiing," which involves skiers paying to be dropped by a helicopter to ski in isolated terrain. Alpine Olympian and ski legend Brookie Dodge, son of Joe Dodge, was an early heliski pioneer.

In 1909, Fred Harris, Dartmouth class of 1911, proposed the idea of forming a ski and snowshoe club—the Dartmouth Outing Club (DOC). Impressed by other carnivals in cities like Montreal, Harris also had a serendipitous meeting on a train with James P. Taylor, a young Vermont Academy teacher who had inspired that school to found an outing club and to create a winter carnival. The story goes that at least one Vermont Academy student helped form the first winter carnival at Dartmouth, held in 1911. The DOC assumed a significant role in the development of skiing in New Hampshire by inspiring a team of avid skiers and hosting the first downhill races in the region.

In April 1914, John S. Apperson of Schenectady, New York, officially reported the first recorded use of skis in Tuckerman Ravine. In 1923, the DOC hired Hungarian Colonel Anton Diettrich, former World War I Austrian ski trooper.

The first slalom race in the United States was held at Dartmouth in 1923, just one year after the first such race occurred in Murren, Switzerland. On March 8, 1927, following up on an idea presented by Anton Diettrich, the DOC organized a down-mountain race on Mount Moosilauke in Warren— the first downhill race in the United States. Charles N. Proctor won with a time of 21:40.

On March 9, 1928, Robert Baumrucker of Dartmouth won the first slalom race in Hanover—based upon rules stating that time is the only factor.

On April 11, 1931, Charles N. Proctor and John Carleton first skied over the headwall of Tuckerman's Ravine. On March 12, 1933, Henry

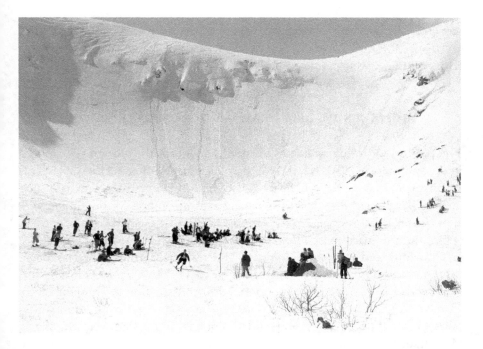

The first giant slalom race in the United States was in Tuckerman's Ravine on April 4, 1937. Dick Dorrance changed the course to the right gully due to recent avalanche activity. *Courtesy New England Ski Museum Collection.*

Woods won the first U.S. National Downhill Championships held on the Moosilauke carriage road. Up until that time, the National Ski Association had only sanctioned ski jumping and cross-country events.

On April 4, 1937, the first giant slalom race was held in Tuckerman's Ravine. At the last minute, course setter Dick Dorrance of Dartmouth rerouted the course to the right gully of Tuckerman's instead of the headwall, due to evidence of recent avalanche activity. Tuckerman's is one of the very few spots in the East where avalanches occur. Blown snow can accumulate to great depths on the headwall, and smooth snowslopes mask and soften underlying cliffs.

On April 16, 1939, in the Third "American Inferno"—a top-to-bottom race of Mount Washington through Tuckerman's Ravine—Austrian Toni Matt, an Eastern Ski School instructor at Cranmore, won by schussing straight over Tuckerman's steep headwall.

In 1966, the Masters Ski Competition held at Attitash signaled one of the first freestyle competitions. Each skier skied three runs demonstrating

ski school technique, followed by two runs "freestyle." Lucy Boynton, age fourteen, of South Conway, and George Hodgkins, age twenty-seven, of Kittery, Maine, won the race.[40]

PIONEERS IN SKI TRAIL AND RESORT DESIGN

The passion for skiing spurred the carving of ski trails through the woods. In the summer of 1933, Kate Peckett of Peckett's-on-Sugar Hill was one of the primary movers in mobilizing the Civilian Conservation Corps to cut the first ski trail—the Richard Taft racing trail at Cannon Mountain, named after the proprietor of the Profile House, an inn that burned down a decade before the trail was built. The CCC hired Charley Proctor to lay out trails in Crawford and Pinkham Notches. The Italian Marquis Nicholas degli Albizzi, the summer equestrian instructor at Peckett's, and Duke Dimitri of Lichtenberg designed and supervised trail construction in Franconia and Waterville. During the summer of 1933, the CCC built more than thirty miles of ski trails. The trails included Wildcat at Pinkham Notch, Black Mountain, Doublehead in Jackson, Bear Mountain in Bartlett and trails in North Woodstock, Intervale and Wilmot Flat.

Originally, trails were only cleared in areas that could not be seen in the valley. The first ski trails were treacherously narrow. Many trails came about through the efforts of skiers bushwhacking their way through the woods, beating pathways down the mountain. Eventually, permission was granted to allow the cutting of trees less than six inches in diameter along those pathways. As people skied faster, more trees alongside the trails became dangerous and those trees were cut, too.

As enthusiasm for skiing grew, the art of cutting a ski trail became a science. That science has to do with crafting trails that follow and enhance the natural contours of a mountain, creating a route that physically and psychologically "draws" the skier down the mountain while offering a thrill that has a rhythm. One skier described that thrill: "The rhythm of a good trail makes skiing feel like dancing."

Sel Hannah, a native of Berlin, began cutting ski trails in the 1930s—possibly trails still used by the Nansen Ski Club. Hannah, a farmer and outdoorsman from Franconia, became New Hampshire's premier ski resort designer, establishing Sno.engineering as the state's first ski design firm. Hannah designed resorts at Cannon, Loon and Waterville Valley and has been a consultant on ski trail and resort design throughout the world.

The Taft Trail on Cannon Mountain, the first downhill ski trail in the country cut specifically for skiing, became a favorite for races due to its width and pitch. *Courtesy New England Ski Museum Collection.*

Prior to the tow era, New Hampshire had more than one hundred trails. As the sport drew ever-greater crowds, the ski industry still relied on consistent weather—an anomaly in New England. If it didn't snow, resorts were in trouble. If it did snow, it was difficult for resorts to maintain trails once they had been skied or to replace snow where wind had swept it away. Initially, in early morning, resort staff and sometimes their guests would sidestep down a mountain on skis to tramp down the snow. As the ski

industry expanded, owners began to experiment with other ways to move snow from one place to another—"grooming."

Early grooming took many forms. One technique was to carry snow on strips of metal from one trail to the other. Another was to "farm" snow; that is, to plow it and then move it. Whereas the first trail groomers focused on creating and maintaining a good ski trail surface, advanced grooming equipment allows groomers to build moguls, snowboard jumps and half pipes.[41]

SKI MECHANIZATION:
FIRST AERIAL TRAMWAY IN NORTH AMERICA

With lessons taught, races run and trails carved, increasing numbers of avid skiers presented the ski industry with the next major challenge—getting skiers to the hill and up the hill.

On January 11, 1931, the first snow train left Boston for Warner, with 197 skiers aboard, sponsored by the AMC. On February 4, 1934, one train to North Woodstock carried 2,933 skiers. In the first three years, the railroad claimed to have transported 40,000 skiers, boosted no doubt by the "snow winter" of 1933–34. Snow trains lured skiers to North Conway. Passengers would board the snow train in Boston before dawn, loaded with luggage and ski gear. Horse-drawn pungs met them at the station and delivered them to the slopes. Snow trains were discontinued in the 1950s when the partygoers began to outnumber skiers.

The best way to maximize ski time was to help skiers get up the mountain. Skiing was suddenly made much easier with the "immoral rope tow," most likely referring to the sudden transformation of the sport from its pastoral past and slower pace to a more frenzied sport focused on speed. Patterned after the first rope tow in North America at Shawbridge, Quebec, in 1933, and the first American rope tow at Woodstock, Vermont, in 1934, a rope tow was constructed at Travena Hill in Lisbon, New Hampshire, on January 20, 1935. The rope tow revolutionized skiing, as skiers could make the same number of downhill runs in a day as they used to do in a month. Suddenly, skiers were packing down the trail through repeated runs, inns opened for a winter season and the experience of skiing changed from a one-day outing to a recreational and social experience.

In late January 1935, Mount Gunstock Ski Hoist, built by C. Cooke of Swampscott, Massachusetts, opened in Gilford—6,200 feet long with a 900-foot vertical rise. The ride took two and a half minutes but was very tiring.

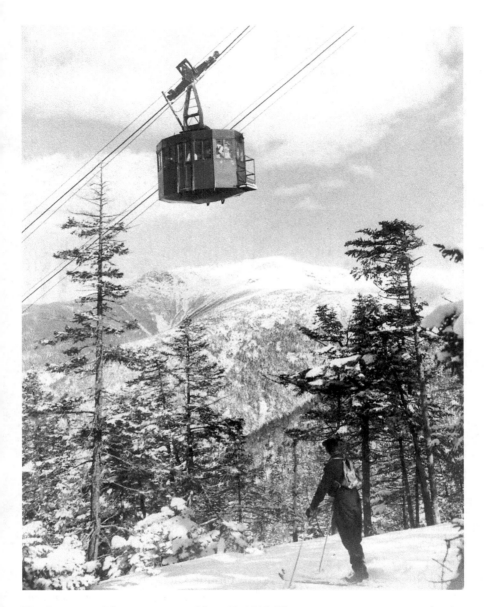

The Cannon aerial tramway opened June 28, 1938. The two passenger cars were painted dark green to blend in unobtrusively with summer foliage in Franconia Notch. *Courtesy New England Ski Museum Collection.*

The Mount Cranmore skimobile opened on New Year's Day 1939. It closed in the late 1980s. *Courtesy North Conway Public Library.*

By the 1930s, aerial tramways had come into vogue in the United States but were used primarily for non-skiing work crews, like the ones constructed by sculptor Gutzon Borglum and used in hauling equipment and workers to the top of Mount Rushmore. In 1935, the Uncanoonuc Ski Club in Manchester built ski trails to be served by the Uncanoonuc Cable Tramway, which had been transporting summer riders for twenty-five years. At Christmas that year, Franconia opened a nine-hundred-foot rope tow and the slope was illuminated.

On January 1, 1936, the Dartmouth Outing Club installed a fifty-foot-J-bar lift on Oak Hill in Hanover, built by Split Ballbearing Corporation of Lebanon, claiming it to be the only ski cable lift in the United States and one of two in the world, a lift that could carry four hundred passengers an hour. During the same season, George Morton invented and installed an overhead cable lift at Moody Farm in Jackson.

Alex Bright, a founding member of the elite Ski Club Hochgebirge and the Woodstock Ski Runners Club, later became 1935 Eastern Downhill

Champion and a member of the 1936 U.S. Winter Olympic Team. In 1933, Bright worked at Cannon Mountain and actively campaigned the American Steel and Wire Company to evaluate tram possibilities at Cannon Mountain, arguing that Europe already had fifty tramways.

On June 17, 1937, the New Hampshire Legislature passed the Tramway Bill into law, appropriating $250,000 for construction of the American-Bleichert-Zuegg Tramway on Cannon Mountain in Franconia Notch—a double, reversible tram system in which one car descends as the other ascends.

In January 1938, two years after the first one was installed at Sun Valley, Idaho, the first single chairlift was installed in New Hampshire on Mount Rowe in Gilford, with fifty chairs transporting two hundred passengers an hour. Dedicated June 17, 1938, the Cannon Mountain Tramway opened to the public the following day as the first aerial tramway in North America. During its first winter season, the tramway transported almost thirty-five thousand skiers. By 1980, when a modern tram replaced the first one, the Cannon Mountain Tramway had transported seven million people.

In 1938, George Morton, not enamored of the idea of dangling his feet hundreds of feet in the air to travel up a mountain, began thinking about a grounded system that would move cars along by a cable. On December 27, 1938, Morton's skimobile made its first run up 1,800 feet, roughly halfway up Mount Cranmore. On New Year's Day 1939, the skimobile transported 1,065 passengers, approximately 255 per hour. On August 1, the 2,000-foot upper portion of the skimobile was completed to the summit. Eventually, the Mount Cranmore Skimobile became obsolete and closed in the late 1980s.

New Hampshire can also claim the first snowmobile (as distinct from a *ski*mobile). The original snowmobile was developed as a converted Model-T Ford, manufactured in Ossipee in the 1920s, complete with rear tracks and front runners, anticipating the perks of the modern snowmobile.[42]

Pioneers in Dog Sledding: Admiral Byrd Expeditions

In 1908, during his second trip to Alaska, Arthur Walden of Tamworth, a veteran dog sledder, acquired a dog named Chinook, a half-breed MacKenzie River dog adapted to Alaska and work, from a gold prospector who had fallen on hard times. When Walden could not bring the dog back to Wonalancet

Farm in New Hampshire, he turned his attention to dog breeding. In an effort to create a breed of friendly, fast and powerful sled dogs, Walden crossed a St. Bernard mix with a direct descendent of Admiral Peary's Greenland husky. Three puppies resulted, which he named Rikki, Tikki and Tavi from *The Jungle Book*, as Kipling was Walden's favorite writer. To honor the dog he had left in Alaska, Walden renamed Rikki Chinook, a most remarkable dog from which would come a remarkable breed. In 1922, Walden's dog teams, led by Chinook, won the first Eastern International Dog Derby and set a record for the forty-mile race, finishing in one hour and fifty-nine seconds.

In 1923, Walden invited celebrated Alaskan musher Leonhard Seppala to race his Siberian huskies against Walden and his Chinooks on Brown Paper Company land in Berlin. Seppala was known for his dog sled run across Alaska transporting serum that saved Nome from an epidemic of diphtheria. The race is credited as the introduction of sled dog racing to people in the lower forty-eight states.

On March 30, 1926, Walden became the first to drive a team, led by Chinook, up Mount Washington, a journey that took eight hours up and six hours down through a blizzard.

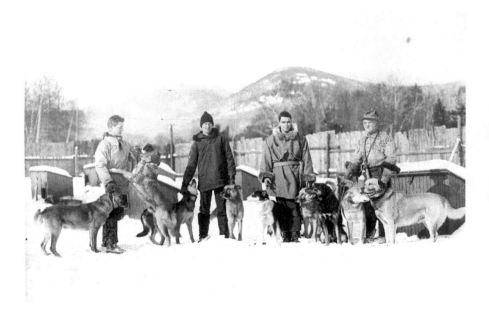

Arthur Walden (right), with Chinook, stands with Harvard graduates Crockett, Goodale and Vaughn, who helped with dogsled teams on the Byrd Expedition, 1928. *Courtesy Rick Skoglund, Perry Greene Kennel.*

When Admiral Richard E. Byrd began recruiting dogs for his South Pole expedition, Walden went to Boston with Chinook to meet Byrd, though at age fifty-six Walden knew he was too old to be considered for the expedition. But by the end of the meeting, Byrd had selected Walden to be in charge of training the dogs, with Walden and Chinook designated the lead team. Over one hundred dogs were sent to Walden at Wonalancet for training. For a year, Walden, along with three assistants, trained and worked with the dogs and tested supplies best adapted to Antarctica conditions.

In 1928, when Byrd's expedition reached the shores of Antarctica, Walden's sled dog team and Chinook set records, carrying 3,500 pounds of supplies from the ship eight miles away to the base camp in just two trips in one day.

On May 9, 1930, Walden returned home from Antarctica to Tamworth to a hero's welcome. "Byrd had the whole world to choose from and he chose Arthur Treadwell Walden," said Harry Hart of Wolfeboro, representative for the governor.

In April 1932, Florence Clark, who was the only woman to participate in the Boston-to-Berlin race in the late 1920s, became the first and only woman to drive a dog sled team to the summit of Mount Washington and back, with her female lead dog Clarkso leading a team of five dogs—setting a new record as the only person to drive a sled dog team to the summit of Mount Washington without assistance.[43]

THE NASHUA DODGERS:
PIONEERS IN THE INTEGRATION OF BASEBALL

In October 1945, Branch Rickey, president of the Brooklyn Dodgers, garnered national attention for his ball club by signing Jackie Robinson with Montreal, the first African American baseball player to receive a professional contract. The same year, to further his "great experiment"—the integration of professional baseball in the United States—Rickey also signed John Wright, Roy Campanella and Don Newcombe. Simultaneously, Rickey formed a new farm team that needed a home. It was 1946 and Rickey called up E.J. "Buzzie" Bavasi, who had just returned from World War II.

In *Dem Little Bums: The Nashua Dodgers*, by former *Nashua Telegraph* Sports Editor Steve Daly, Bavasi recalled:

> *On my discharge, my wife and I and our young son had leased a*
> *home in Sea Island, Georgia, with the intent to take a year off before*

Roy Campanella (left) and Don Newcombe at Nashua's Holman Stadium, 1946. *Courtesy Steve Daly.*

joining the Dodgers. However, Mr. Rickey summoned me to New York and asked if I would operate a club in the New England League for one year. He was having difficulty finding a city for Roy Campanella and Don Newcombe to play in. Kish Bookwalter, owner of the Danville, Illinois, club, did not think his city was ready for such an adventure. I was then asked to find a city where the young men would be welcome. After talking to the Nashua Telegraph's managing editor, Fred Dobens, I knew that Nashua was the place. Thus came the Nashua Dodgers.

The Dodgers had over twenty minor league clubs at the time, but the Dodgers did not want Newk or Campy to start in a high classification. But all the lower classifications were in towns like Pine Bluff, Paducah, Hazzard, Daytona Beach—mostly in the Deep South. The choice of Nashua turned out to be perfect. The citizens of Nashua fell in love with Newk and Campy, and they in turn loved playing there. I'd have to say that Fred Dobens made it all possible.

The Nashua Dodgers became the first integrated baseball team in the United States since the late 1880s, when an unwritten agreement between owners excluded African Americans from professional baseball teams.

Behind the scenes, Dobens and *Telegraph* sports editor Frank Stawasz made it happen through insightful promotional tactics. First, they created a connection between the Nashua Dodgers and the children of Nashua. Bavasi announced a baseball school to be held at Holman that would be managed by Clyde Sukeforth, the chief scout for the Brooklyn Dodgers, who had started his career with the Nashua Millionaires in 1926. Bavasi's new "Knot-Hole Club" enabled fifteen hundred schoolchildren to attend games for thirty cents a game, less than half of the seventy-four-cent general admission price.

The plan worked. Nashua fans enthusiastically accepted Newcombe and Campanella. In May 1946, Newcombe became the first African American pitcher to win a game for an integrated professional baseball team in the twentieth century.

The twenty-four-year-old Campanella remarked to *Pittsburgh Courier* reporter Wendell Smith, "I don't see how a guy can help but be a good ballplayer in a town like this. Newcombe and I go any place we want to, do anything we please, and are treated like long-lost sons, it's wonderful."

Bavasi said at the close of the season, "I believe that the city of Nashua had a great deal to do with the way other cities handled racial problems. Had Nashua not accepted Roy and Don with open arms, who knows what might have happened elsewhere, [I] think baseball owes a debt of gratitude to the folks in Nashua."[44]

FORESTS
AND MOUNTAINS

"First Citizen": The Old Man in the Mountain

Within a small, tree-shadowed space
I can look up and see a Face,
Ice-chiseled long ago.
If I desert that favored sphere,
The noble features disappear
And only ledges show.
It all depends on where I stand
If shapeless rock or something grand
Is visible to me.
And what I choose to keep in view
Becomes a part of all I do
And all I hope to be.

So Francis Hancock wrote of "Old Stone Face" in 1946. The *recent* legacy of the Old Man of the Mountain, though only a memory now, owes its existence, in very large part, to the Niels Nielson family, who, for three generations, took care of the rocky profile that had come to signify the Granite State. To Niels Nielson and his family and the caretakers of the Old Man who preceded them, the Old Man was not only a treasure to see, but also a phenomenon worth preserving with all the ingenuity that man could muster.

In 1960, Niels Nielson went to work for the State of New Hampshire as a bridge construction foreman in charge of the crew that did maintenance work on the profile. Care of the Old Man has been the charge of Niels and his son David since 1965. In 1981, Niels and David Nielson became

the first pair of men to simultaneously go down over the front of the Old Man, which meant hanging in midair from three-eighths-inch cable with no safety net, over an eight-hundred-foot drop to the mountain slope twelve hundred feet above Profile Lake. David's initiation was a dramatic one. Something happened to his father's line, and he had to hang on the side of the mountain for twenty minutes while David coolly orchestrated a way to rescue him. In 1990, when Niels retired, David began to lead the Old Man maintenance crews.

David, a Belmont police sergeant, met his future wife, policewoman Debbie Goddard, at a stakeout. When Nielson asked her to have lunch with him and told her he was caretaker for the Old Man, she did not believe him. Their second date was a hike to the Old Man. In 1990, Debbie became the first woman to go over the side of Great Stone Face, the same year their son Tom, age nine, first came to the mountain.

Ever since 1805, when Luke Brooks, Franconia's tax collector and surveyor, looked up from the edge of Profile Lake, where he had pitched camp to gaze upon a mountain profile, preservation of the Old Man essentially became the work of committed individuals rather than the government. Admirers judged the Old Man to be both safe and inaccessible until the 1870s, when members of the Appalachian Mountain Club pinpointed the location of the Old Man and reported that one forehead boulder had moved well away from the rest of the forehead. In 1906, Reverend Guy Roberts, a Methodist minister from Whitefield, hiked to the Old Man and observed the danger to the profile itself if the forehead stone should fall and strike the nose. He pointed out the danger, but no one knew what could be done.

In 1915, Reverend Roberts met Edward Geddes, a granite quarry superintendent from Quincy, Massachusetts, who said he could fix the problem in much the way he secured precarious ledges in the quarry. He would hook one rock to another with turnbuckles—metal rods that rotate and lock. In September 1916, Geddes climbed to the Old Man amid rain and snow. It took him seven days to drill six holes by hand and install three turnbuckles. The rocks he secured did not move measurably.

Over the years, the Nielsons have removed debris, installed wire mesh and epoxy membranes, installed checkpoint pins for measuring resealed cracks, taken strain tests, painted the turnbuckles with asbestos fiber-filled paint for protection and maintained the canopy installed in 1958 to keep the forehead rock from sliding down the mountain. Geddes was a one-man crew working twelve-hour days, hiking two hours in and two hours out from the Old Man. In the recent past, maintenance crews had grown with the

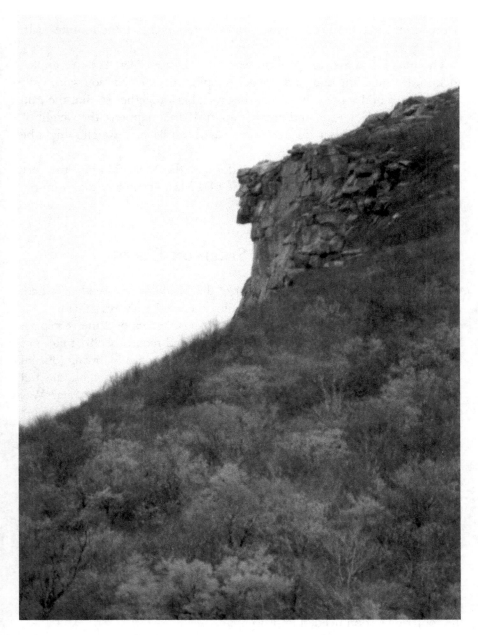

"Old Stone Face," 1985. *Photo Credit: E.W. Whitney III.*

concern for safety and travel time had been reduced to three minutes with a helicopter.

The major concern for Nielson was the "keystone" or "Adam's apple" rock under the chin that had started to split. In 1992 Nielson said, "We are trying to find some way to seal that rock back together so that the rain doesn't get inside, freeze, and break it apart. If that happens, the weight of the face of the Old Man, due to the increased cantilevered weight, might be enough to take the Old Man away."

On May 3, 2003, despite the best efforts of the Nielson family, the very same freeze-thaw cycles that carved the Old Man eventually took him off the face of Cannon Mountain.[45]

FASTEST WIND SPEED ON EARTH

On Mount Washington, renowned home of the "world's worst weather," where sun can turn to fog, rain or snow in minutes, the wind is always a factor.

On April 12, 1934, Mount Washington Observatory meteorologist Salvatore Pagliuca recorded the world wind speed record of 231 miles per hour, a record that stills stands today. Pagliuca wrote the following journal entry: "'Will they believe it?' was our first thought. I felt then the full responsibility of that startling measurement. Was my timing correct? Was the method OK? Was the calibration right? Was the stopwatch accurate? Slowly, I began collecting the evidence." A new heated anemometer developed in late 1932 measured the world record.

Beginning June 5, 1871, high winds atop Mount Washington had been consistently observed by the United States Signal Corps for more than seventeen years. The observatory journal reported that anemometer cups were being blown off and records lost as late as 1886.

By October 1932, the time of re-occupancy of the summit of Mount Washington for meteorological observations, a conventional anemometer was replaced by one specially designed to include a cup-wheel rotor with a stationary electric stove unit, connected to the 110-volt D.C. gasoline-electric unit of the observatory. This anemometer, installed eight feet above the roof ridge, soon needed improvements.

Using a design modeled after one shown to Dr. C.F. Brooks by Dr. Sverre Pettersson of the Norwegian Weather Service in Bergen, Norway, in 1931, D.W. Mann of the Mann Instrument Company of Cambridge, Massachusetts, eventually built the new heated anemometer in conjunction

with Sterling M. Fergusson and others at Blue Hill Observatory in Milton, Massachusetts, completing it in 1933. The instrument was tested in the wind tunnel at the Guggenheim Aeronautical Laboratory of the Massachusetts Institute of Technology before it was installed atop Mount Washington in March 1933. After an initial false start due to bad installation of Number 1, the Number 2 Heated Anemometer, which differed only in small detail from the first, was completely installed March 20, 1933. Just over a year later, that anemometer recorded the fastest wind on earth.

This record was called into question on December 16, 1997, when Anderson Air Force Base in Guam reported a peak wind of 236 miles per hour during Typhoon Paka. However, after extensive research into the details of that recording by a multi-agency assessment team, the National Climate Extremes Committee announced on March 11, 1998, that the wind gust report from Guam was unreliable based on site surveys, ground and air assessments.

Measurements of tornadoes in May 1997 caused some to wonder if this famous record had again been challenged when researchers in

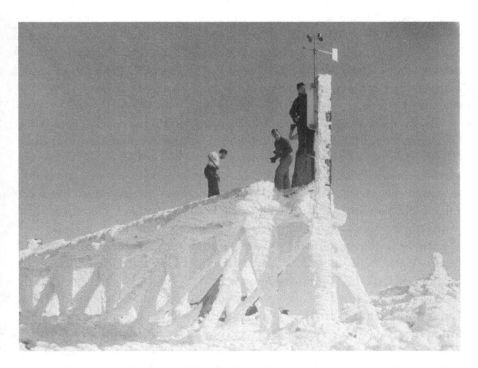

Meterologist Salvatore Pagliuca and Joe Dodge setting up anemometer on railroad trestle, October 15, 1932. *Photo Credit: Harold Orne. Courtesy Mount Washington Observatory Collection.*

Oklahoma released wind data of 318 miles per hour occurring during a storm. According to staff meteorologist Sarah Curtis, "Those readings, and similar high wind measurements from other tornadoes, indicate winds some height above the earth. Our mountain record remains the highest surface wind yet measured."

The record surface wind atop Mount Washington still stands.[46]

The Earliest Continuous Mountain Footpath in the United States

It is one thing for a pioneer to carve a path in the wilderness, but something else entirely for that pioneer to be hospitable to those who come behind.

In 1771, Timothy Nash, a pioneer from Lancaster, New Hampshire, followed the trail of a moose over Cherry Mountain and found that an old Indian trail passed through a ravine. When Nash made his way through the notch in the mountains south to Portsmouth and sought out Governor John Wentworth to tell him of his discovery, Wentworth promptly commissioned Nash, saying, "Bring a horse down from Lancaster through this pass and show me it's a practicable route for settlers and I shall grant you some land." Though Nash and Benjamin Sawyer managed to drag rather than ride a horse through the notch and, in doing so, gained 2,184 acres of land, nothing else happened with the fortuitous path through the notch until fifty years later.

Visitors to the White Mountains today owe much to the generosity of Abel Crawford. In 1791, news of this notch through the mountains enticed Abel Crawford, a powerful woodsman, to leave his life in Guildhall, Vermont, and his new wife Hannah Rosebrook, pregnant with their second child, to find his own way to this path. When he reached the Fabyans, Crawford encountered squatters most willing to sell rights to the land. He moved into one of their crude log shelters and lived there alone for many months.

Early in 1792, Crawford brought his wife and two boys, Erastus and Ethan Allen, to live beside the river Indians called the Ompompanusuc, today known as the Ammonoosuc, where Abel built his cabin on a place called "Giant's Grave," a three-hundred-foot-long glacial mound. When Hannah's father, Eleazar Rosebrook, came to visit them, he was so struck by this home in the wilderness that he offered to buy his son-in-law out. Abel accepted and, needing elbow room, moved twelve miles south. Rosebrook became an innkeeper, offering food and lodging for those traveling through

the notch. Eventually, when Rosebrook appealed to his grandson Ethan to move back to his father's original home to keep him company, Ethan did so. Shortly after, Ethan married Lucy Howe, a cousin who had moved into the house to care for his grandfather.

In 1818, a party of men from Boston asked Abel Crawford to be their guide to the top of Mount Washington. At the time there was no trail, so the trees were thick, the stream crossings treacherous and the underbrush shredded the men's expensive clothing—and still, they were forced to turn back never having reached their goal. In September of that year, two men, again accompanied by Abel, reached beyond the timberline and made it to the summit, bringing with them a brass plate inscribed in Latin, which they affixed to the topmost rock—a plate stolen by vandals in 1825.

By 1819, Ethan Allen Crawford had established himself as both guide and innkeeper, just as his grandfather had done. In *History of the White Mountains*, published in 1845, Lucy Crawford, wife of Ethan Allen, recounts in her husband's words the tale of how Ethan and his father Abel cut a path from

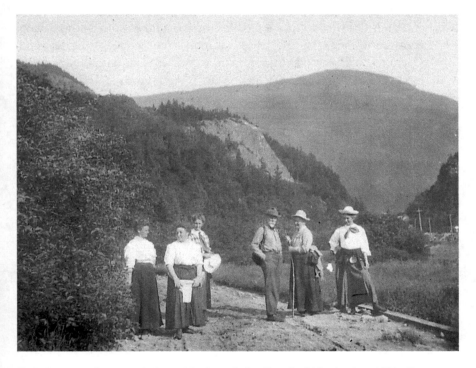

Early "trampers" rest on their ramble through the Crawford Notch, circa 1890. *Courtesy Appalachian Mountain Club.*

the head of the notch to the summit of Mount Washington. "My father and I made a foot path from the Notch out through the woods, and it was advertised in the newspapers, and soon we began to have a few visitors."

The generosity of Ethan Allen Crawford is implied on every page of Lucy's tale. She recounts a day in May when a man and woman spent the night with the Crawfords. The next morning, when twelve inches of snow kept them from moving their wagon, Ethan Allen removed the wheels, placed his guests and their wagon on a sleigh, attached his horse to a sled and pulled them to Bethlehem, a distance of twelve miles. The spirit of the Appalachian Mountain Club hut system in the White Mountains owes its existence to the hospitable spirit of the Crawford family, the first innkeepers in the Whites.

In 1820, a group of men from Lancaster—including Philip Carrigan, secretary of state of New Hampshire noted for his great map of the state—asked Ethan to guide them to the summit of Mount Washington by way of his new path. This party proceeded to name the highest peaks of the White Mountains after the presidents of the United States, the idea being to name them in chronological order. At the time, Adams, Jefferson and Madison were officially named.

Ethan Allen Crawford considered hospitality synonymous with making a life in the mountains. In 1823, when a man from Boston commissioned Ethan Allen to build a good carriage road to which $200 had already been subscribed, Ethan Allen refused, saying (in Lucy's words): "I did not feel able to build an addition to my house, and I well knew that if I made this road, and did not have suitable accommodations for those who would be likely to come, it would only be imposing upon the public to have a road to the Mountain and not have house room enough to make those comfortable who came to stay with us."

Crawford Notch and the Crawford Path bear the name of a generous family of mountain innkeepers who not only carved a path but, despite yearly erosion from rain and snow, kept rebuilding that path so those who followed could enjoy the scenic grandeur of the Presidentials. The Crawford Path became popular for almost thirty years, until the invention of the Mount Washington Cog Railroad. But in 1876, the formation of the Appalachian Mountain Club rejuvenated interest in hiking this old trail.[47]

First Mountain-climbing Train

One day in August of 1857, Sylvester Marsh began a hike up Mount Washington with Reverend Thompson of the Eliot Church in Roxbury,

Massachusetts. Marsh and Thompson were caught in a storm and overtaken by darkness and exhaustion by the time they finally reached the Tip Top House on the summit. That night, Marsh fell asleep dreaming of an easier way to reach the summit.

In 1857, people said Sylvester Marsh, who was born on a farm in Campton, amidst the foothills of the White Mountains, must be crazy to think he could build a train that would climb a mountain. Marsh was not an engineer, a mechanic or a railroad man. Yet Marsh believed in and adopted the idea for a cog system railway, first proposed by inventors Herrick Aiken and his son Walter Franklin.

In fact, in 1858 Marsh took his "perfect model," as he referred to a model that worked, to Concord to apply to the state legislature for a charter to build a steam railroad from the base to the summit of Mount Washington. When his bill was read in the house, a universal outburst of laughter followed as one bodacious legislator suggested an amendment granting Marsh permission to extend his mountaintop railroad to the moon!

Despite six years of rejection, Marsh kept to his goal. In the winter of 1865, with $5,000 of his own money added to contributions totaling $20,000

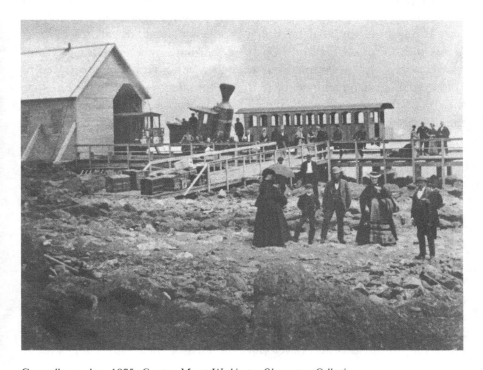

Cog railway, circa 1875. *Courtesy Mount Washington Observatory Collection.*

from the Boston, Concord and Montreal Railroad, the Connecticut and Passumpsic Railroads, the Concord Railroad and the Northern Railroad, Marsh formed the Mount Washington Steam Railway, a stock company.

A year later, Marsh built the first engine that was used throughout the first stage of construction of the railroad. On August 29, 1866, Marsh demonstrated his railway. The steam engine successfully pushed a flat car carrying invited passengers up the mountainside over the first quarter mile of track. Upon descent, the brakes were released and the speed was controlled through compression of air in the cylinders. Newspaper accounts of the event were sent from the base station via a telegraph line that had been strung across the mountain in 1864.

Marsh officially named his locomotive Hero after Hero of Alexandria, believed to have lived in the third century AD, because one device described in the "Pneumatics" of Hero was the "aeliopile," a primitive steam engine. However, when one spectator observed that the engine with its upright boiler and smokestack looked more like a long-necked pepper sauce bottle, the nickname "Peppersass" stuck.

In 1893, after many years of service up and down Mount Washington, Old Peppersass was retired, replaced by more modern engines, and was taken to the World's Fair in Chicago to be put on display. On its return to New Hampshire, it was intended that Peppersass should travel on the tracks across the Ammonoosuc and stop there, but fame was its undoing. When movie actors and newspapermen wanted to photograph it from Jacob's Ladder, the old steam engine made the ascent safely, but due to the fact that the size of the cogs had been changed, the venerable old engine slipped on the descent and ran away; luckily, there were no fatalities.[48]

OLDEST CONSERVATION AND MOUNTAINEERING CLUB IN AMERICA

The fact that science was as important as scenery to early naturalists like Edward C. Pickering, a twenty-nine-year-old MIT physics professor and founder of the Appalachian Mountain Club, charted a course of serious intent for the oldest mountaineering club in the United States that has produced ripple effects far beyond the scope of the White Mountains.

As early as 1873, when men were organizing the Portland White Mountain Club and the Alpine Club of Williamstown, Pickering was hiking the White Mountains and developing the idea of forming a club devoted

to hiking unascended peaks, elevation measurements, recording data, trail building and mapping, rather than pursuing the amusement-driven focus of the Portland Club.

On January 1, 1876, Pickering invited fifty of his peers "to attend a meeting of those interested in mountain exploration." They gathered a week later on January 8, in room eleven of the Rogers building on the MIT campus. Among those present were Portland outdoor club enthusiast Edward T. Morse, a professor newly appointed to Harvard, and Samuel H. Scudder, a Williamstown Alpine Club organizer now in Cambridge as a Harvard lecturer in zoology. In just a few weeks' time, thirty-four self-assured and well-organized founding members drafted a constitution and appointed councilors in the fields of exploration, art, nomenclature, topography, improvements and natural history.

These early pioneers and explorers took copious notes of each hike and, using their collective expertise and the latest technological tools—including the inclinometer and the pocket sextant—plotted points from which they created elaborate, supremely accurate maps. In fact, in 1960, Maine AMC members who used aerial photography found no errors in Louis Cutter's 1898 map of the White Mountains.

A band of coed hikers gather in autumn sun in 1890 outside the two-year-old Madison Spring Hut. *Courtesy Appalachian Mountain Club.*

Following an excursion to Europe, the councilor of improvements suggested building a mountain hut between Mount Adams and Mount Madison, a place for "cooking utensils and axe and a good supply of fuel at hand." In 1888, AMC members built Madison Spring Hut with two-foot-thick walls of stone for a cost of $701.65.

Even though early hikers collected alpine plants and insects—scarcely the activities of conservation—other conservation efforts of AMC members inspired the creation of the Middlesex Fells Reservation in 1889, from which came the Massachusetts Trustees of Reservations. In 1933, famed AMC hutmaster Joe Dodge played a central role in the formation of the Mount Washington Observatory.

The passage of the dramatic Weeks Act of 1911 that established the White Mountain National Forest signaled the culmination of a decade of outdoor activism by the Appalachian Mountain Club and the Society for the Protection of New Hampshire Forests. Throughout its history, the AMC has lobbied actively for conservation efforts across the country, supporting legislation on issues of the protection of forests, rivers and clean air. Today, the scope of the twenty-five-thousand-member Appalachian Mountain Club is wider than ever, encompassing care for an intricate network of trails, huts, shelters and camps; conservation; and the development of outdoor recreation, from backpacking and rock climbing to snowshoeing, Nordic and alpine skiing and whitewater canoeing.[49]

FIRST MOUNTAINTOP NEWSPAPER: *AMONG THE CLOUDS*

Storm-bound atop Mount Washington during the summer of 1874, Henry Burt surveyed the cog railway, the carriage road, the first-rate hotel, post office and telegraph office, and remarked, "There ought to be a newspaper here for those who have to wait for the clouds to lift."

A seasoned newspaper editor who had published papers in towns from Boston to Bellevue, Nebraska, Burt set up shop in the front room of the old Tip Top House, which served as business and editorial quarters in addition to a composing and press room. Burt's son Frank, who worked many summers for his father, recalled, "It was an exciting moment when the equipment, including a Campbell cylinder press (turned by hand), arrived on an open platform car pushed by a cog railway locomotive."

In the July 18, 1877, first edition, postdated July 20, Burt wrote of his passion for the mountains in his opening editorial: "We never feel so near

Established in 1877.

The Oldest Summer
Resort Newspaper
In America.

The Only Newspaper
Printed on the
Summit of any
Mountain in
the World.

Printed Twice Daily on the Summit of Mount Washington.—6300 feet Above the Sea.

July 28, 1898 *Among the Clouds* masthead used for Henry Burt's mountaintop newspaper. *Courtesy Mount Washington Observatory Collection.*

the Infinite as when looking up these lofty mountains and the thousand beauties that are limited only by human vision." When Burt discovered visitors wanted a paper to announce their summit visits, he began printing two daily editions of *Among the Clouds* to coincide with the noon and evening arrivals of trains and stagecoaches. Mountain reporters covering the coaching parades in the 1890s caught the last train to the summit, writing their stories as they traveled up the mountain.

Snow or sleet, rain or shine, the newspapers were printed, folded by hand and bundled in time for a three o'clock departure, when railway men with

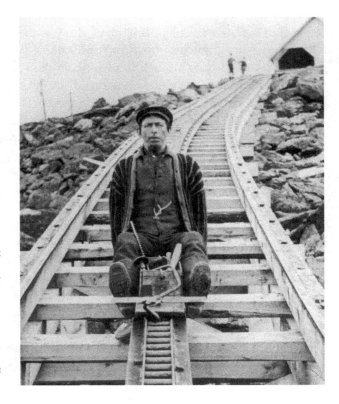

To demonstrate the technique used to deliver papers, a summit mechanic poses for a photograph while sitting on his "devil's shingle." Note the lack of papers between his knees and the wrench wedged in the cog rack to prevent descent, circa 1870. *Courtesy Mount Washington Observatory Collection.*

123

bundles between their knees would climb aboard slide boards, sleds fitted to the cog railway nicknamed "Devil's Shingles." These "paper trains" arrived at the base of the mountain in ten minutes. A wagon pulled by swift horses would deliver the papers to Bethlehem or to the first train going through Crawford Notch, reaching readers before breakfast, thereby "scooping" all the city newspapers.

The printing office quickly became a regular point of interest, where many mountain visitors first saw a printing press. At the end of the first season, Burt wrote, "It is not often that a member of the typographical fraternity has an opportunity to set type in so elevated a place as the Summit of Mt. Washington, and those who came as visitors to the office of *Among the Clouds* availed themselves of the privilege."

An avid mountain photographer, Burt pursued the image as well as the word. For more than twenty years, he could be seen roaming above the timberline with pressman Edward Mehan, toting a great square camera and heavy glass plates. "To take a picture it was necessary…to attach a big box to a tripod, set it up…with stones against the feet of the tripod for ballast, pull out the bellows of the camera in front, and then hang on for dear life lest the whole affair be swept away by the force of the prevailing wind," wrote Burt's grandson Allen. Burt never fully recovered from a thirty-foot fall he took while photographing the headwall of Tuckerman's Ravine. He died in 1899. In honor of the man whose work in words and pictures did so much to reveal the White Mountains to the world, the ravine between Mounts Washington and Clay as seen from Jacob's Ladder was named Burt's Ravine. *Among the Clouds* came to an abrupt end in 1919 when the printing shed burned and an apprentice died in a "shingle-express" descent.[50]

Oldest and Largest Private Wild Game Preserve

In the late 1880s, a certain restlessness took Austin Corbin II far from his native Newport, New Hampshire, to Davenport, Iowa, where he was a successful lawyer and the banker who obtained the first federal bank charter issued in the country. After he had amassed a fortune worth several millions as a railroad magnate and president of Long Island, Reading and Pennsylvania Railroads, Corbin eventually returned home to build a summer residence in Newport.

In 1888, Corbin bought several tracts of land near Croydon Mountain amounting to twenty-five thousand acres in the towns of Newport, Croyden

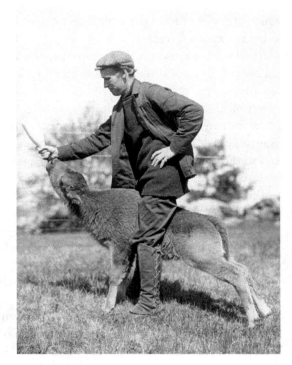

Ernest Harold Baynes, chosen by industrialist Austin Corbin II as the naturalist for Corbin's private wild game preserve, feeding a buffalo calf. *Courtesy Plainfield, New Hampshire Historical Society.*

and Grantham to establish a wild game preserve, which he incorporated as the Blue Mountain Forest Association. To fulfill his controversial dream, Corbin purchased 63 farms totaling 265 different land transfers that encompassed five townships and the summits of three mountains: Stowell Hill, Grantham Mountain and three-thousand-foot-high Croydon Peak, overlooking the Sugar River Valley.

In hard economic times, local residents chided such extravagance, referring to the land as "Corbin's folly." Despite his preservation aims, Corbin was criticized in New York newspapers for his purchase of "a big worthless chunk of New Hampshire wilderness populated by wild animals and thickly scattered with granite boulders." Undaunted by such criticism, Corbin hired renowned natural scientist and bird defender Ernest Harold Baynes as the naturalist for his private game preserve.

Because he had witnessed firsthand the vanishing of bison on the plains of Iowa, Corbin had as his original mission the desire to save the American bison or buffalo, a species rapidly becoming extinct. The buffalo made quite a stir in town when they arrived by train and were then herded up the road by cowboys. Despite local criticism, Corbin's bison thrived, descendants of

which are said to have populated every large zoo in the country, in addition to being exported west.

In addition to bison, Corbin also imported what he described as "all the animals of the world that can live together harmoniously," which included bighorn sheep, moose, antelope, elk, deer and wild boars from the Black Forest of Germany. To contain the animals, Corbin built an extensive wire fence that ran eight feet above the ground and three feet below ground, ostensibly to prevent escape. The moose died out. The wild pigs escaped and so did the elk, so many of them that a one-day elk hunting season was declared in the 1940s.

Today, this largest private game sanctuary in the United States still exists, although, according to local residents, it may be one of the best-kept secrets of the Granite State.[51]

PIONEERS IN FOREST MANAGEMENT

The northern forest of New Hampshire might be a very different place today were it not for the foresight and passion of one man and his family—William Wentworth Brown. Brown, whose leadership transformed the north country into a working forest, explained his philosophy: "I attribute what little success I have made largely to following one line of business and sticking to it through good times and bad."

The northern forest stretches from Watertown, New York, to Fort Kent, Maine. With its 23 million acres of privately owned land and 5 million acres of public land; 68,000 miles of streams and rivers; 2.5 million acres of wetlands; 7,000 lakes covering 1 million acres; and 1 million people, with just 50 people per square mile, there are a lot of precious resources in need of protection.

Geographically, Berlin, New Hampshire, is in the center of this region. From the 1860s to the 1930s, William Wentworth Brown made it the capital of the northern forest by transforming Berlin and the surrounding areas into a major industrial city, combining prudent use and management of forest resources with a dedicated workforce and a utopian business vision.

In 1868, W.W. Brown had a growing family and a net worth of $50,000 that he had made by selling ships' knees and decks to the shipbuilding industry. By 1910, the Brown Company had become an internationally known pulp and paper production center. But Brown did more than transform wood into paper; he invested in community. Berlin and the Brown Company logging camps drew an array of European immigrants

often recruited for their specific skills in forestry, ironwork, stonecutting and masonry. German, Scandinavian, Irish, Russian and Italian immigrants working at Brown Company logging camps tended to live in ethnically centered neighborhoods because of language differences. But they found community not only at work in the mills, but also at a community YMCA—built in 1913 at a cost of $100,000, made possible by the donations of land, money and time from the Brown Company. The YMCA included a gymnasium, running track, bowling alleys, an indoor heated pool and recreation and reading rooms.

Modeling after his visionary father, William Robinson Brown, the third son of W.W. Brown, took forest management to a utopian level, pioneering the concept of "sustainable yield." W.R. Brown visited the logging camps often, exercising a practical, hands-on approach to management. He studied forestry science and investigated the techniques of respected high-ranking forest officers in Germany.

Previously, loggers had clear-cut and moved on. Brown was the first executive in the timber industry to hire a professional forester, recruiting from the celebrated School of Forestry at Yale. His staff did original research on tree growth and genetics, ran the largest private tree nursery in the country and sponsored yearly conferences that attracted foresters and forestry researchers from around the globe. W.R. Brown developed pioneering methods within the forests,

William Robinson Brown, visionary forester.
Photo Copy: Mark R. Ducharme. Courtesy Northern Forest Heritage Park.

too, creating the first woods safety program in the region; he built efficient logging camps with professional cooks and the best equipment.

In 1901, W.R. Brown became a founding member of the Society for the Protection of New Hampshire Forests. With the passage of the Weeks Act of 1911, W.R. Brown's passion for forest protection spurred him to offer the government thirty thousand acres of Brown Company land on the northern slopes of the Presidential Range—the first land tract forming the new White Mountain National Forest.

Brown's pioneering spirit pervaded the research laboratory as well. In 1903, Hugh K. Moore was hired on as a laborer for the Brown Company but spent his spare time doing research. In 1913, Moore, who had been conducting research at MIT, convinced the Brown Company to set a building aside for research. By 1917, a large research building was built. Eventually, the Brown research staff numbered more than one hundred, making it one of the first and largest corporate research facilities in the country, and the first in the paper industry.

By the 1920s, the Brown Paper Company owned 3.75 million acres of forest in northern New England and Canada, the precise number of acres William Robinson Brown figured he would require to meet the needs of his New Hampshire and Quebec paper mills, "without ever cutting the forest faster than it was growing."

The Museum of New Hampshire History is located in the Old Stone Warehouse, Eagle Square, Concord, its bright green fire tower cab protruding above the roofline. *Photo Credit: D. Quincy Whitney.*

W.R. Brown, spurred by a series of tremendous forest fires and his mission to preserve and protect New Hampshire forests, created the fire tower system still in use today in the Granite State. Fire towers were a central part of nineteenth- and twentieth-century New Hampshire history. New Hampshire is the second most forested state in the nation, with 4.8 million acres of forestland that make up 84 percent of its total terrain. The New Hampshire fire tower system peaked in the 1940s, when over fifty towers existed. The lighthouses of the mountains, fire towers have been replaced by the technology of aerial surveillance in combination with government funding cuts. While all federal fire towers in the state have closed, sixteen state-run fire towers still operate—spotting six hundred fires annually, while providing weather and foliage information, and hosting twenty thousand hikers each year who climb fire towers in order to view the many mountain vistas of New Hampshire.

In 1994, in tribute to the long history of forestry and forest protection in the Granite State, the New Hampshire Historical Society commissioned Gosselin Steel, Inc., of Auburn, New Hampshire, to build a simulated fire tower in the newly renovated Old Stone Warehouse, the new home of the Museum of New Hampshire History. Today visitors willing to climb the winding granite staircase can climb all the way to the top of the museum's fire tower to enjoy panoramic views of central New Hampshire in all directions from the bright green cupola that sits atop the fourth floor of the museum.[52]

First Organization to Protect Forests

In 1867, just as the Civil War bore witness to the substantial land use changes resulting from the transition from a rural America to the Industrial Age, New Hampshire relinquished all of its "wildlands," approximately 172,000 acres, including Mount Washington, for $25,000. At the time, politicians who had separated themselves from the "burden" of public land did not anticipate how quickly logging companies would be attracted to this land. Soon, other citizens became concerned about rapidly disappearing wild lands.

On February 6, 1901, a group of eight men and one woman, including Governor Frank West Rollins, founded the Society for the Protection of New Hampshire Forests, the first forest conservation advocacy group in the United States. The society hired Philip Wheelock Ayres as first forester and staff leader of the organization.

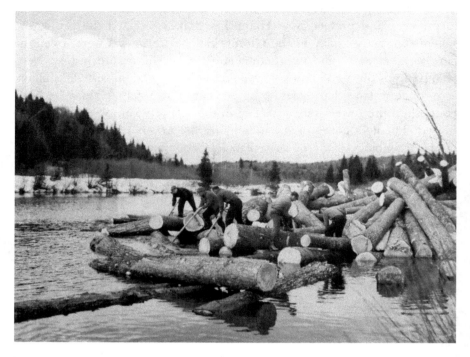

Logging on the river, Berlin, 1890s. *Photo Copy: Mark R. Ducharme. Courtesy Northern Forest Heritage Park.*

The society soon found Ayres to be a tireless advocate for the conservation of public lands. Ayres had been born on a farm, and had been a *Baltimore Sun* reporter, educator and charitable society administrator before he came to direct the SPNHF. He became one of the first men to obtain his degree in forestry from Cornell University. When New Hampshire Governor Frank Rollins, one of the founders of the society, called Ayres to his position, Ayres latched on to the opportunity to save the White Mountains. An avid campaigner who understood media well, Ayres took on his first campaign to create a national forest in the White Mountains.

In 1908, the Society acquired Lost River Gorge as a permanent reservation. To follow, society acquisitions saved Franconia and Crawford Notches, Lost River, Mount Monadnock, Mount Sunapee and Mount Kearsarge. In 1909, the Society advocated for the creation of a state forestry department and state nursery, as well as urged the enactment of fire prevention laws. In 1911, with the passage of the Weeks Act, the Society

created a national forest system for the East by acquiring 300,000 acres of the Presidential Range, the core of today's 800,000-acre White Mountain National Forest.[53]

First Mount Washington Road Race

Appropriately enough, the Mount Washington Auto Road was built because of the challenges of winter. In lieu of the fact that there were no ice-free seaports from which Canadian farmers could ship their wheat each winter, a railroad was built from Montreal to Portland in 1851. It passed through Gorham, opening up the east side of the White Mountains to the tourist trade.

The building of the "Carriage Road" was an enormous challenge, as the nearest supply source was eight miles away and the only mode of transportation was horse and oxen. Dynamite did not yet exist, so black powder was the explosive used and blasting holes had to be hand drilled. Work began in 1854 and it took two years to reach the halfway house. When the money ran out, a new company was formed in 1859. The next year when work resumed, the first tolls were collected for passage to the halfway house.

The gala opening of the road to the summit occurred on August 8, 1861, and competition had already begun. Colonel Joseph Thompson, proprietor of Glen House, drove his horse and carriage to the summit three weeks before the official opening—when the road was still strewn with boulders—to make sure of beating his rival, Colonel John Hitchcock, who owned the Alpine House. More than thirty years hence, it was only a matter of time before the "horseless carriage" ushered in a new era on the carriage road.

On August 31, 1899, F.O. Stanley, accompanied by his wife Flora, drove a Stanley Steamer up the Carriage Road. In the summit newspaper *Among the Clouds* on September 1, 1899, Stanley described driving "the First Locomobile" up the mountain.

> *As the carriage is constructed for road use we found it necessary in climbing the mountain where the average grade for eight miles is approximately 12 percent, to jack up the rear wheels and run the engine for a few minutes in order to supply sufficient water to the boiler. In other respects the journey up the mountain was as free from any interesting incident as the same distance traveled on level.*

On August 31, 1899, Mr. and Mrs. Freelan Stanley climbed to the summit of Mount Washington in the "First Locomobile." *Courtesy Mount Washington Auto Road Archives.*

Flora described their arrival at the summit:

> *We had sufficient steam to take us beyond the seven-mile post, and there we waited until our water supply was replenished. At last we rounded the gulf and came in on the home stretch with flying colors. The excursionists and summit residents were crowded on the north end of the platform and on the roof of the woodshed to catch the first glimpse of the Locomobile.*

The Stanley Steamer had only fifteen moving parts—no spark plugs, no transmission, no clutch, no gear shift—yet Flora did not describe a precarious descent.

"Everyone said: 'Don't you dread the ride down the mountain?' But that proved as easy as rolling off a log," said Flora. "We reversed the engine, played the brake like an organ pedal, just held on and let the thing spin. We stopped at the HalfWay House long enough to pay the toll, which was $1.92. We reached the foot of the mountain in one hour, making the last half of the trip in twenty minutes."

Who were the judges in the 1904 Mount Washington auto race? Journalists, of course. *Courtesy Mount Washington Auto Road Archives.*

It is apparent from the Carriage Road log that the directors of the road did not anticipate the predominance of the automobile. The first time they allowed automobiles, they did so for only four days. On June 28, 1904, the journal of the directors' meeting stated: "It was noted that we allow automobiles and any motor vehicles to pass over the Road on July 11, 1904– July 16, 1904…at no other times shall they be allowed on the road and that the supervisors be instructed to place a gate across the road at the base of the mountain to enforce the regulation by all reasonable means."

On July 12, 1904, in the first auto race up Mount Washington, F.O. Stanley's twin brother F.E. Stanley took second place to the Mercedes driven by Harry Harkness, who set the record at 24 minutes, 37³/₅ seconds. A contemporary account of the race reported:

Something more…was to be expected from the 60-horsepower $18,000 Mercedes, and from this comparative view the performance was not extraordinary. As a feat of driving, however, it was remarkable. To guide

*2,200 pounds of mechanism up an 8-mile narrow mountain road, and
to pull up just 4,600 feet above the starting point after averaging 20
miles an hour without a stop is sure enough a test of man and machine.*

The Mount Washington Auto Road had just hosted the nation's oldest
motor sports event.[54]

FIRST BIRD CLUB

On September 13, 1913, at eight o'clock in the evening a masque—a
lavishly costumed pantomime masquerade based on a mythical theme—
was presented in a meadow in Meriden, New Hampshire, to celebrate the
forming of the Meriden Bird Club by ornithologist Ernest Harold Baynes.
The debut performance of "Sanctuary: A Bird Masque," created by Percy
MacKaye, honored the newly formed Meriden Bird Sanctuary, located on
thirty-two acres of pasture and woods.

President Woodrow Wilson and the first lady were in the audience to
watch one of their daughters, Margaret, sing the opening song and another
daughter, Eleanor, perform the lead role as the Bird Spirit. In 1913, the
summer White House was the mansion of novelist Winston Churchill, a few

Ornithologist and naturalist Ernest Harold Baynes, renowned for his ease with animals, sits
with his tame fox, 1906. *Courtesy Plainfield Historical Society.*

miles from the Meriden-Cornish area. Also in the audience were Bird Club Committee members Maxfield Parrish, Charles A. Platt, Joseph Lindon Smith and Mrs. Augustus Saint-Gaudens, members of the Cornish Artist Colony. The performance dramatically summarized the passion of Baynes, a naturalist driven to protect birds.

Baynes had been an impassioned naturalist all of his life. As a young reporter disgruntled by his experience at the *New York Times* and the *Boston Post*, he decided to write about what he loved—nature. In 1901, Baynes sold his first article on wild life, illustrated by his fiancée, Louise Birt O'Connell, to the *New York Herald* for twenty-five dollars. The couple married and moved to Stoneham, Massachusetts, on the edge of the Middlesex Falls Nature Reserve, where they enjoyed such unusual house pets as snapping turtles, flying squirrels, hawks and snakes. Lectures on wildlife brought Baynes notoriety that led to articles in prominent magazines of the day—such as *Scribners*, *St. Nicholas* and *Munsey's*—and eventually led to a syndicated newspaper column on wildlife.

On a lecture tour in the Midwest, Baynes visited the Cincinnati Zoo and saw the last passenger pigeons on earth nearing death, the last remnants of a flock once estimated at more than two million birds. On June 8, 1910, impassioned by the plight of birds endangered by the ladies' hat industry, Baynes gave a famous lecture "How to Attract Wild Birds" at Kimball Union Academy in Meriden. The impressionable youth raised $25 for the cause. On December 7, 1910, the Meriden Bird Club was organized in the Kimball Union Chapel. A month later on January 7, 1911, Baynes held the first official Bird Club meeting. "Bird fever" spread throughout the town, inspiring even Connecticut resident Helen Woodruff to donate $1,000, allowing the club to acquire a thirty-two-acre abandoned farm as the "Bird Sanctuary" in 1911.

A contemporary observer described Bayne's bird sanctuary:

> *Paths lead through the woods, bird houses of every type hang from trees, and drinking pools are numerous amid the ferns. Bird baths are placed at intervals, one a boulder weighing 5 tons; another of bronze and sculptured by Annetta (Mrs. Louis) Saint-Gaudens in commemoration of the bird masque, "Sanctuary," first performed here in 1913.*

Baynes took the bird masque on the road with the Chautauqua Circuit, performing it in 120 towns for an estimated 200,000 people. The culminating performance was held February 24, 1914, at the Hotel Astor

in New York City under the patronage of Mrs. Woodrow Wilson. That performance drew an audience of 2,000. Both President Wilson and ex-President Roosevelt commended Baynes for his efforts. As a result, by 1916, over two hundred bird clubs had been formed in twenty-three states. It has been said that the Meriden Bird Club spawned two-thirds of the bird clubs in the United States.[55]

SEA, LAKE, SKY

First Warships Built in North America

In 1690, over a hundred years before the official formation of Portsmouth Naval Shipyard, the British government chose the renowned port of Portsmouth as the place to build ships for the Royal Navy. That year, the first contract for the construction of the 637-ton, fifty-four-gun frigate HMS *Falkland* was awarded. The *Falkland* was the first warship to be built in North America. This contract initiated a long tradition of nearly three hundred years of naval vessel shipbuilding, thereby attracting a significant population of skilled shipbuilders and specialists to the Piscataqua River region.

HMS *Falkland* was officially added to the Royal Navy on March 2, 1695. The thirty-two-gun HMS *Bedford* followed on May 3, 1697. In 1749, the sixty-gun HMS *America* was built in the North Mill Pond shipyard operated by Colonel Nathaniel Meserve. The exquisitely detailed model for this ship, the oldest known ship's model in the country, sits at the Portsmouth Athenaeum in Portsmouth, New Hampshire.

In 1775, to prepare for war to achieve independence, the Continental Congress authorized the building of six ships in Portsmouth on Badger's Island, which had been offered for shipbuilding use for the Continental navy by owner John Langdon. In 1775, work began on the thirty-two-gun *Raleigh*, marking the actual birth of the Portsmouth Naval Shipyard that did not become official until 1800.

Two years later, the eighteen-gun *Ranger* was completed, which John Paul Jones sailed in 1777 for his historic raids of the British Isles. The seventy-four-gun *America* became the third ship laid down during the Revolutionary War, finally completed in 1782. It was the heaviest ship ever laid down in the continent of North America, and the first ship of its class built by the colonies.

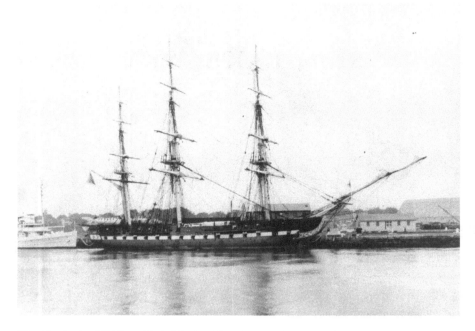

The *Constitution* (Old Ironsides), July 3, 1931, the most famos ship overhauled at the Portsmouth Naval Shipyard (1855). *Courtesy University Archives, University of New Hampshire.*

America was built on the shore of the Piscataqua River. Captain John Paul Jones directed its launching, which was made difficult by shallow waters and the angle at which the keel had been laid. The newly formed United States gave *America* to France in appreciation of that country's assistance during the Revolutionary War and to reciprocate for the accidental loss of the French fourteen-gun ship *Magnifique* in Boston Harbor in 1782.[56]

THE PISCATAQUA RIVER GUNDALOW

History has proven that boat design often evolves directly out of the peculiar needs of people and their environment. "The Piscataqua River gundalow was the heavy-duty freight truck of its time," said gundalow captain Michael Gowell as he sat on the deck of the *Captain Edward H. Adams*, the replica gundalow named for the last gundalow skipper who sailed the river basin in the 1880s. The *Captain Adams* was built and launched in 1982 with the help of oxen to the cheers of four thousand onlookers at Prescott Park, where it

is docked each summer to call attention to the long and peculiar tradition of the Piscataqua River gundalow.

Named after their ancient predecessors, Venetian gondolas, gundalows go back as far as the Nile River feluccas, boats that still use lateen sails— triangular sails attached to a long rod suspended from a short mast. Built by farmers in need of cargo vessels rather than by boat builders, gundalows were uncomplicated in construction and handling. For three centuries, gundalows transported farm produce, bricks, cotton, firewood, as well as gossip and news to people living and working along the Piscataqua River.

Environmental eccentricities of this particular river basin determined the design of the Piscataqua gundalow. In order to maneuver the second-fastest tidal current in North America in waters as shallow as they are swift, Piscataqua River gundalows had to have broad beams for stability and be able to draw very little water. To accommodate the low bridges of the region, both sail and supporting rod had to drop quickly as the vessel sailed under a bridge, and then rise quickly to catch the breeze without losing momentum.

Originally undecked barges powered by tide, wind and long oars in the 1600s, Piscataqua River gundalows evolved into partially decked barges with square-rigged sails. By the 1800s, gundalows had full cabins and lateen sails. "The Piscataqua River gundalow developed into a sophisticated form, with a spoon bow and stern, a lateen sailing rig, and this sort of size. In most places, they were dumb barges with no means of propulsion of their own," explained Gowell in an interview in 1994.

In fact, the peculiar design of the Piscataqua River gundalow makes the *Captain Edward H. Adams* difficult to sail without an engine to challenge the swift current. "Sailing her is somewhere between exhilarating and terrorizing. It's easy to make her go and hard to make her stop. She weighs almost 50 tons, and there's 1,100 square feet of sail there. And it's proportioned just right. She's not oversailed, but there's a lot of force. Visitors can come on deck but we do not take her out. She's a great teaching platform but she's unwieldy," said Gowell.

Today the Gundalow Company uses the *Captain Edward Adams* as a teaching platform from which to educate school groups and the public about New Hampshire's maritime history and environmental issues related to the Piscataqua River basin. Through a full schedule of "dockside" programs conducted at various riverside locations from May through November, combined with in-classroom winter programming, the Gundalow Company serves an audience of fifteen thousand annually.

Artist's rendering of the age of the Piscataqua gundalows. *Courtesy Rye Historical Society.*

Reminiscent of the first gundalows that sailed the Swampscot and the Lamprey Rivers connecting to Great Bay, the Oyster and Bellamy Rivers flowing into Little Bay and the Cocheco and Salmon Falls Rivers emptying into Portsmouth Harbor, the replica *Captain Adams* continues to connect the past with the present, carrying its message about a river basin that requires future river dwellers to be stewards of its waterways.[57]

FIRST GOVERNMENT-SANCTIONED SHIPYARD IN THE NATION

At the end of the American Revolution, focus turned to developing a new government. In 1798, the navy separated from the War Department and a Department of the Navy was formed. Benjamin Stoddard, new secretary of the navy, recognized the need and efficiency for the new United States government to have a shipyard of its own. Stoddard asked Chief Naval Constructor Joshua Humphries to survey possible shipyard sites. After surveying New England

coast sites from New London, Connecticut, to Wiscasset, Maine, Humphries chose Fernald's (Dennett's) Island in Portsmouth.

He listed its advantages: inexpensive to fortify; accessible to the sea; a sufficient supply of stone for building; a suitable place for docking timber; and a dock sheltered from the winds. Stoddard also listed disadvantages: small harbor; rapid current; coast subject to fogs; hard stony bottom; and dangerous passage through narrows except at slack water.

On June 12, 1800, the secretary of the navy recommended to President Jefferson the purchase of Fernald's Island from William and Sarah Dennett for the price of $5,500. That same year, land was purchased at Washington, D.C., Philadelphia and Brooklyn, New York, but the Portsmouth Naval Shipyard was the first government-sanctioned shipyard established in the United States. The clock in the tower of Building 13, former Naval Base Headquarters, is said to be the first clock in the United States Navy to strike ship's bells rather than the hours. In 1879, shipyard worker H.H. Ham obtained the patent rights to the striking mechanism that has since been repaired but not changed.

In 1834, the U.S. Navy authorized construction to begin on one of the largest ship houses in the nation. In its original form, the ship house measured 240 feet long, 131 feet wide and 72 feet from floor to ridge, with a 130-ton slate roof. The first warship built and launched from the ship house was the sixteen-gun war sloop *Preble*.

The ship house was later named the Franklin Shiphouse, named for the USS *Franklin*, built within the Franklin Shiphouse from 1854 to 1864. The

Portsmouth Navy Yard and ceremony on Bridge #1. *Courtesy University Archives, University of New Hampshire.*

USS *Franklin*, the largest steamship constructed in the navy at the time, was launched September 17, 1864, to great fanfare along the banks of the Piscataqua River.

Many navy vessels were built in the Franklin Shiphouse, including submarines, until it burned to the ground in 1936.[58]

FIRST INTERCOLLEGIATE ROWING REGATTA

In the summer of 1852, James M. Whiton, a Yale junior and a crew member traveling on the Boston, Concord and Montreal train passing between Weirs and Laconia, got talking with his friend, railroad superintendent James N. Elkins. Naturally, the subject of Lake Winnipesaukee came up and the fact that the Winnipesaukee River, as it emerges from the lake at the Weirs, widens into an expanse of smooth water ideal for a rowing regatta. The discussion evolved into a challenge from Elkins to Whiton: "If you will get up a regatta on the lake between Yale and Harvard, I will pay all the bills." Elkins also offered to advertise the race widely and run excursion trains to the race.

The challenge was on. Since Yale's term did not end until July 29, two weeks after Harvard's, Harvard had to marshal a team together—thus, the August race date. On August 3, 1852, a cloudless, moderately warm day with a light northwest breeze, before a cheering crowd of a thousand, the boats gathered—Yale's *Shawmut* and *Undine* to Harvard's *Oneida*, "a crack boat of its kind." Perhaps the most distinguished known celebrity to attend the race was General Franklin Pierce, who was then campaigning for president against General Winfield Scott.

Harvard won. One report said that *Oneida* finished four lengths ahead of *Shawmut* and eight lengths ahead of *Undine*, while official records for Harvard and Yale report the distance as "about two lengths."

The second half of the regatta planned for August 5 at Wolfeboro, the other end of Lake Winnipesaukee, was called off due to a storm—not on the lake but in Boston—that prevented excursion trains from running. The boats gathered for a mock race. *Oneida* won handsomely again. General Pierce presented the regatta prize—a pair of silver-mounted, black walnut sculls.

Racing shells have been much improved and standardized since this first collegiate rowing competition. In 1852, boats were shorter and wider with stiff bottoms, forty-five feet long and three and a half feet wide,

Flyer advertising the 1952 centennial regatta honoring the Harvard-Yale Lake Winnipesaukee race on August 3, 1852, the first intercollegiate rowing regatta in the nation. *Courtesy Lake Winnipesaukee Historical Society.*

compared to modern boats measuring sixty-one feet and two feet wide. At first, oars varied in length, with the middle oarsman using the longest oar. Now all crew members use a standard-sized oar measuring approximately twelve feet.[59]

ISLES OF SHOALS SAILING REGATTA: FIRST AMERICA'S CUP?

By June 1873, John Poor had managed the completion of the building of the Oceanic Hotel, a new resort on Star Island, the second largest of the Isles of Shoals located nine miles out from Portsmouth harbor. The new resort boasted an extravagant two-hundred-foot stone pier for the steam ferry and a swimming area in a sheltered cove created from sand shipped from the southwest side of the island, an area too narrow and exposed to allow safe swimming.

As Oscar Laighton recalled in his memoir *Ninety Years at the Isles of Shoals*, Poor celebrated the opening of the Oceanic by sending invitations to all

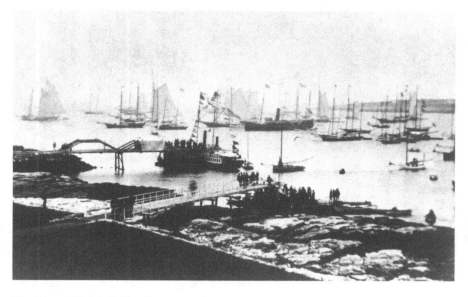

The Isles of Shoals Sailing Regatta on June 20, 1873, won by Civil War General Ben Butler with his yacht *America*, for which the America's Cup is named. *Courtesy University Archives, University of New Hampshire.*

New England yacht clubs and yacht owners "to meet at the Oceanic and race for a valuable cup." On June 20, 1873, over fifty yachts journeyed to Star Island to sail a race from the Shoals to Boon Island and back, participating in what became known as the "Grand Opening Regatta" for the Oceanic Hotel.

According to Laighton,

> *Five hundred yachts were soon in our harbor. The race was around*
> *Boon Island, thirteen miles to the northeast, and back around a spar*
> *buoy at Appledore. The race was won by the yacht "America," with*
> *Colonel French and General Butler on board. The race brought so many*
> *objectionable people to the Oceanic that their exclusive guests moved over*
> *to Appledore to escape the noise and confusion.*

Civil War General Ben Butler won the race with his yacht *America*, the most celebrated racing yacht in the country, for which the America's Cup races are named. Eventually, the Oceanic's remote island location resulted in its downfall. On November 10, 1875, the Oceanic was struck by lightning, and with so few residents to fight the fire, the hotel burned to the ground.[60]

PIONEERS IN SUBMARINE TECHNOLOGY

In 1914, the Portsmouth Naval Shipyard was chosen as the first site for a submarine to be built at a U.S. Navy yard. In 1917, when the *L-8* was completed in the Franklin Shiphouse at a substantially lower cost than the contract price, the secretary of the navy designated the Portsmouth Naval Shipyard as a submarine yard. As the first and only yard on the Eastern seaboard with extensive experience in submarine technology, the Portsmouth Naval Shipyard became the home yard for all submarine construction on the East Coast. From 1917 to 1941, thirty-three submarines were completed at the Portsmouth Naval Shipyard and the Design Division in Portsmouth became leaders in the field of submarine design. About one half of all the submarines performing in World War II were constructed at the Portsmouth Naval Shipyard.

The first ongoing underwater explosion tests in the Portsmouth Naval Shipyard, held in 1937, convinced submarine designers of the superiority of the all-welded steel submarine hull over the riveted hull. When the submarine *Snapper* was commissioned on December 15, 1937, at Portsmouth,

it featured the first all-welded steel hull. The welded steel construction enabled the submarine to submerge deeper, to three hundred feet in depth, and to better withstand attacks. After *Snapper*, all navy submarines featured all-welded hulls.

In 1941, Naval Shipyard Planning Officer Andy McKee was credited with the most significant advancement in submarine design during World War II with the development of a "thick-skin" submarine, whereby increasing the thickness of a submarine nearly doubled its operating depth, resulting in the BALAO submarine design.

Another innovation pioneered at the Portsmouth Naval Shipyard involved the GUPPY program (Greater Underwater Propulsive Power; the "Y" was added for euphony). The GUPPY conversion featured improving submergibility by streamlining the hull and increasing battery capabilities, thereby increasing speed and endurance. The USS *Odax*, commissioned in July 1945, became the first submarine transformed by a GUPPY conversion.

According to Richard Winslow III, the *Albacore*, known as the "fastest, quietest and most maneuverable underwater boat of her day," was one of the most important submarines in the history of the United States Navy because it heralded the era of pure scientific experimentation to determine submarine design.

In 1948, Rear Admiral Charles B. Momsen said, "In the old days, design became a four ring circus. The Bureaus of Ordnance, Engineering, Navigation and Construction and Repair all vied with one another to get their own projects included." To circumvent this problem, the idea was approved that the *Albacore* should be designed solely on the basis of improved submergibility. Submarine designer Eugene Allmendinger, who worked on the *Albacore* throughout its history, said the submarine was designed to be a "full-scale floating hydrodynamics laboratory."

Albacore was launched August 1, 1953. That year, another innovation, the invention of the Portsmouth test tank, allowed *Albacore* designers to accurately simulate the hydrostatic pressure exerted on a submarine over time. Cracks in the hull were studied and tested, leading to improvements in design and the use of new steel alloys.

On August 27, 1957, the U.S. Navy launched the USS *Swordfish* at the Portsmouth Naval Shipyard, the first atomic-powered submarine built at a government-owned shipyard. Previously, Electric Boat Company in Groton, Connecticut, first accepted the challenge of Hyman G. Reckoner, chief of the Naval Reactors Branch of the Atomic Energy Commission, and built the first three nuclear submarines in the world in the early 1950s. In 1960,

"Who bats first? Sonarman Konicki and Lieutenant Leahy fight it out before the ball game...The *Seadragon*'s sail can be seen in the background." August 25, 1960. *Courtesy University Archives, University of New Hampshire.*

Swordfish became the first nuclear submarine to cruise the Western Pacific, as Pearl Harbor was its home port.

Modeled after an Electric Boat design, the USS *Seadragon* was the second nuclear submarine built at the Portsmouth Naval Shipyard. On August 1, 1960, *Seadragon* sailed north on its voyage through the Northwest Passage to the North Pole. Eight days later, it entered Baffin Bay, near Greenland, known for its extensive icebergs. *Seadragon* became the first submarine in the world to dive under icebergs, some so thick the submarine had to dive more than three hundred feet to clear passage.

On August 15, *Seadragon* spent three days navigating the little-known bottleneck Barrow Straith, followed by the deeper McClure Strait and the Arctic Basin, thereby completing the first submerged voyage through the Northwest Passage.

Upon its arrival at the North Pole on August 25, *Seadragon* surfaced through an unexpected area of open water in the middle of sea ice. A group of "Seadragonites" dressed in special electronic "ice suits" rowed a life raft to a neighboring ice cake, laid out a baseball diamond and played the first baseball game on top of the world. Because of the international dateline time zones, players hit a home run ball that would land on the next day, and ran to first base, but arrived twelve hours later.

On September 14, when *Seadragon* arrived at Pearl Harbor, the historic voyage had taken 11,231 miles, but 10,415 of those miles had been navigated under water or under ice.[61]

First American in Space

After April 1961, when Yuri Gagarin of the Soviet Union orbited the earth in Vostok 1, President Kennedy is reported to have said, "We are behind and it will be some time before we catch up." Just ten months later, Alan B. Shepard Jr. became the first American to journey into space, even though the voyage was far short of an orbital flight.

Shepard rode in a Mercury spacecraft, 302 miles downrange from the Florida launching pad. He was aloft for fifteen minutes, reaching a peak altitude of 115 miles. Both astronaut and capsule were easily recovered, providing proof that both man and capsule could survive a short ballistic flight.

In *We Seven*, Shepard wrote:

> *Nobody knew, of course, how much shock and vibration I would really feel when I took off. There was no one around who had tried it and could tell me; and we had not heard from Moscow how it felt...One minute after lift-off the ride did get a little rough. This was where the booster and the capsule passed from sonic to supersonic speed and then immediately went slicing through a zone of maximum dynamic pressure as the forces of speed and air density combined at their peak. The spacecraft started vibrating here. Although my vision was blurred for a few seconds, I had no trouble seeing the instrument panel. I decided not to report this sensation just then.*
>
> *I heard a roaring noise as the escape tower blew off. I was glad I would not be needing it any longer. I had hoped I could see the smoke from the explosions blow past the portholes when this happened, but I*

Alan B. Shepard Jr. *Courtesy NASA and Christa McAuliffe Planetarium.*

was too busy keeping track of the various events on the instrument panel to take a look…and then I heard a noise as the little rockets fired to separate the capsule from the booster. This was a critical point of the flight, both technically and psychologically. I knew that if the capsule got hung up on the booster, I would have quite a different flight…Right after leaving the booster, the capsule and I went weightless together and I could feel the capsule begin its slow, lazy turnaround to get into position for the rest of the flight.

It was now time to go to the periscope. I had been well briefed on what to expect…I had some idea of the huge variety of color and land masses and cloud cover which I would see from 100 miles up. But no one could be briefed well enough to be completely prepared for the astonishing view I got…It was breath-taking…All through this period, the capsule and I remained weightless. And though we had had a lot of free advice on how this would feel—some of it rather dire—the sensation was just what I had expected it would be: pleasant and relaxing.

The Christa McAuliffe Planetarium is undergoing a major expansion to pay tribute to Alan B. Shepard Jr. and Christa McAuliffe. The expansion will transform the planetarium into the McAuliffe-Shepard Discovery Center, a two-story air and space museum, the largest science center in northern New England. The forty-five-thousand-square-foot McAuliffe-Shepard Discovery Center will house two floors of interactive exhibits on astronomy, aviation, Earth and space science, a Challenger Learning Center, a rooftop observatory and the most advanced planetarium theater in the Northeast.

Jeanne Gerulskis, planetarium director, has been working a decade to make the new center happen. "When we started this project, I had no idea that Christa considered Alan Shepard her hero. Christa's mother said that when people would say she was a hero, she would say, 'No, I am not the hero. Alan Shepard was the hero; he went into space when it was a total unknown.'"[62]

FIRST PRIVATE CITIZEN IN SPACE: CHRISTA MCAULIFFE

Christa McAuliffe, social studies teacher from Concord High School in Concord, New Hampshire, and a finalist in the teacher-in-space contest conducted by the National Aeronautics and Space Administration, believed in the importance of teaching, and used every opportunity to discuss the importance of education in society.

Christa McAuliffe. *Courtesy NASA and Christa McAuliffe Planetarium.*

During the selection process of the contest, candidates were asked about their philosophy of life. According to her mother, Grace George Corrigan, Christa answered that "her philosophy was first to get as much out of life as possible, to be flexible to try new things, and to connect with people." Christa's motto was: "I touch the Future: I teach."

On January 28, 1986, when Christa perished along with her six crew mates in the space shuttle Challenger disaster, she left behind an unusual legacy, "an ordinary woman on an extraordinary mission," in many ways, as her friend and *Boston Globe* journalist Bob Hohler related in his book *I Touch the Future...*

In her book *A Journal for Christa*, Grace Corrigan describes the legacy of Christa McAuliffe:

> *Our daughter is a hero, a real hero, but perhaps not for the reasons you might think. She is not a hero because she died while seeking to expand her knowledge and to explore space. She is not a hero because she took a calculated risk as the first private citizen to venture into space. She is not a hero because she brought such needed credit to a great but beleaguered Profession.*
>
> *She is a real hero because she actually did with her life what each of us is capable of doing with our own lives. Christa lived. She never sat back and just existed...she extended her own limitations. She cared about her fellow human beings. She did the ordinary but she did it well and unfailingly. And, as the media brought Christa before the nation, we all recognized in her what we like best in ourselves as a people—modesty, unselfishness, effort, exuberance, generosity, a sense of fun, and the ability to overcome fear.*
>
> *The real heroes are people like Christa, people like parents and teachers who help children in ways they may never even realize. Real heroes are people who take everyday problems without losing sight of who they are and of what is important, in stride and persevere without ever losing sight of who they are and of what is important.*[63]

NOTES

Home, Town, Community

1. "The Museum's History: Settlement and Early Urbanization: 1630–1700," Strawbery Banke Museum, http://www.strawberybanke.org/museumshistory.html; http://www.strawberybanke.org/sitemap.html.

2. Richard D. Holmes, *A View From Meeting House Hill, A History of Sandown New Hampshire* (Peter E. Randall, Publisher, 1988); Federal Writers' Project, WPA, *New Hampshire: A Guide to the Granite State* (Boston: Houghton-Mifflin, 1938).

3. D. Quincy Whitney, *Boston Globe New Hampshire Weekly*, May 3, 1992; "Canterbury Shaker Village: About the Village," http://www.shakers.org/index.php?option=com_content&task=view&id=109&Itemid=135.

4. *The Story of Peterborough Town Library as found in early records*, in the *History of Peterborough, Book One*, George Abbot Morison and Etta M. Smith (Rindge, NH: Richard R. Smith, Publisher, 1954); recent town reports, printed by the Peterborough Savings Bank, Peterborough, NH, Spring 1967; Reverend Levi W. Leonard, DD, "Libraries and Societies," *History of Dublin*, continued with additional chapters to 1917 by Reverend Josiah L. Seward, DD (Town of Dublin, 1920); Federal Writers' Project, *New Hampshire*.

5. Tamara K. Hareven, *Family Time and Industrial Time, The relationship between the family and work in a New England industrial community* (Cambridge, MA: Cambridge University Press, 1982); *Amoskeag Bulletin*, September 15, 1914; Maurice D. Clarke under supervision by his uncle John B. Clarke, *Manchester, A Brief Record of Its Past and Picture of its Present* (1875); Colonel William Parker Straw, *Amoskeag in New Hampshire—An epic in American Industry* (New York: Newcomen Society of England, American Branch, 1948).

6. Mary Rose Boswell, Executive Director, The Belknap Mill Society, *The Historic Belknap Mill 1823–1993* Calendar, The Belknap Mill, Laconia, 1993.

7. John Borden Armstrong, *Factory under the elms: a history of Harrisville, New Hampshire, 1774–1969*, Published for the Merrimack Valley Textile Museum by the M.I.T. Press, 1969.

8. "Factory Girls Meeting," *Dover Gazette and Strafford Advertizers*, March 4, 1834; Laurel Thatcher Ulrich, *The Age of Homespun: Objects and Stories in the Creation of an American Myth* (New York: Knopf, 2001).

9. Ernest L. Scott Jr., "Sarah Josepha Hale's New Hampshire Years, 1788–1828," *Historical New Hampshire* 49 (Summer 1994); Patricia Okker, *Our Sister Editors, Sarah Josepha Hale and the Tradition of Nineteenth-century American Women Editors* (Athens: University of Georgia Press, 1995); Richard F. Leavitt, *Yesterday's New Hampshire* (Miami, FL: E.A. Seeman Publishing, Doc., 1974).

10. M.J. Pullins, *The Mary Baker Eddy Library News Release*, October 24, 2006; "Mary Baker Eddy: Life," Mary Baker Eddy Library, http://www.marybakereddylibrary.org/marybakereddy/life.jhtml; "A Biographical Sketch: Mary Baker Eddy," http://www.endtime.org/intro/mbe.html; "The Boston Insider: The Mary Baker Eddy Library for the Betterment of Humanity," http://www.theinsider.com/Boston/attractions/2christi.htm.

Government, Politics and War

11. Robert H. Whittaker, *Land of Lost Content* (Dover, NH: Alan Sutton Publishing, Inc., 1993); Richard E. Winslow III, *The Piscataqua Gundalow: Workhorse for a Tidal Basin Empire.* Portsmouth Marine Society, Volume 3 (Portsmouth: Peter E. Randall, Publisher, 2002); Leavitt, *Yesterday's New Hampshire.*

12. Karen E. Andersen, "Pursuant to the Trust Reposed in Us," in *New Hampshire Years of Revolution 1774–1783*, edited by Peter E. Randall (Portsmouth, NH: New Hampshire Profiles, New Hampshire American Bicentennial Commission, Profiles Publishing Corporation, 1976); Federal Writers' Project, *New Hampshire.*

13. Hugh Gregg and Georgi Hippauf, *Birth of the Republican Party, A Summary of Historical Research on Amos Tuck and the Birthplace of the Republican Party at Exeter, New Hampshire* (Nashua, NH: Resources of New Hampshire, Inc., Publisher, 1995); Leon W. Anderson, *To this Day, the 300 Years of the New Hampshire Legislature* (Canaan, NH: Phoenix Publishing, 1981).

14. http://www.mrlincolnswhithouse.org/content_inside.asp?ID=20&subjectID=2; http://www.thefells.org/history.

15. Anderson, *To This Day*; Ronald Jager and Grace Jager, *New Hampshire: An Illustrated History of the Granite State* (Woodland Hills, CA: Windsor Publications, Inc., 1983); Elizabeth Forbes Morison and Elting E. Morison, *New Hampshire: A Bicentennial History* (New York: W.W. Norton & Company, Inc., American Association for State and Local History, 1976); Leavitt, *Yesterday's New Hampshire.*

16. Portsmouth Peace Treaty 1905–2005, http://www.portsmouthpeacetreaty.com/process/; Bill Porter, "Portsmouth honors Roosevelt peace effort," *Boston Globe*, December 10, 2006, http://www.boston.com/news/local/articles/2006/12/10/portsmouth_honors_roosevelt_peace_effort; Charles B. Doleac, Esq., "The Portsmouth Peace Treaty: 100th Anniversary Exhibit Explores the Impact," Center for Global Partnership, http://www.cgp.org/index.php?option=arrticle&task=default&articleid=336.

17. Personal interview with Steve Barba.

18. Armand Van Dormael, *Bretton Woods: Birth of a Monetary System* (New York: Holmes and Meier, 1978); William Keegan, "Order, gentlemen, please," *Observer Guardian*, January 11, 2004, http://observer.guardian.co.uk/print/0,,4833469-102271,00.html; *Walking Tour, The Mount Washington Hotel*, Staff and Management, Mount Washington Resort; Kent St. John, Senior Travel Editor, "The Grande Dame Plus Nature's Glory: Mt. Washington Hotel of New Hampshire," June 23, 2005, GoNOMAD.com, http://www.sogonow.com/archives/2005/06/the_grande_dame_1.php.

19. Douglas Sloane, *Coincidence? The Why…The Wherefore of Cathedral of the Pines* (Rindge, NH: Cathedral of the Pines, Publisher, 1962); Samuel P. Hopley, "He Built an Altar" (Rindge, NH: Cathedral of the Pines, Publisher, 1967).

Ingenuity and Enterprise

20. Dartmouth History, http://dartmouth.edu/home/about/history.html; "The Wheelock Succession of Dartmouth Presidents," http://www.dartmouth.edu/~presoff/succession/eleazar.html; Barbara Brown Zikmund, ed., *Hidden Histories in the United Church of Christ* (Cleveland, OH: United Church Press, 1984); "Orozco at Dartmouth: the epic of American Civilization," Hood Museum of Art, Dartmouth College, 2007.

21. Harry N. Scheiber, "Coach, Wagon, and Motor-Truck Manufacture, 1813–1928," in *Abbot-Downing and the Concord Coach*, Harry Scheiber (Concord: The New Hampshire Historical Society, 1989); Elmer Munson Hunt, "Abbot-Downing and the Concord Coach," *Historical New Hampshire*, New Hampshire Historical Society (November 1945).

22. Richard Sanders Allen, *Covered Bridges of the Northeast* (Brattleboro, VT: Stephen Greene Press, 1974); National Register of Historic Places Inventory Nomination Form, November 21, 1976; National Register of Historic Places Inventory Nomination Form, 1974; Richard G. Marshall, Chief of System Planning, comp. and ed., *New Hampshire Covered Bridges, A Link With Our Past* (Nashua, NH: New Hampshire Department of Transportation, TDS Printing, 1994).

23. Helwey Elkins, *Fifteen Years in the Senior Order of Shakers* (New York: AMS Press, 1853); Wendell Hess, *The Enfield (N.H.) Shakers—A Brief History*, Bicentennial Edition. Enfield: Self-published. Wendell Hess, 1993); Stephen J. Stein, *The Shaker Experience in America: A History of the United Society of Believers* (New Haven and London: Yale University Press, 1992).

24. Linda McShane, *When I Wanted the Sun to Shine, Kilburn and Other Littleton, New Hampshire Stereographers* (Littleton, NH: Sherwin Dodge, Publisher, L. McShane, 1993); Paul R. Clay, comp., *Littleton and the White Mountains* (St. Johnsbury, VT: C.T. Ranlet, Publisher, 1898); John H. Colby, ed., *Littleton Crossroads of Northern New Hampshire* (Canaan, NH: The Town of Littleton, Phoenix Publishing, 1984).

25. L.K.H. Lane, "Gems of the New Hampshire Shore," *The Granite Monthly: A New Hampshire Magazine devoted to History, Biography, Literature, and State Progress* 19, Concord, NH (1895); *Odiorne State Park Natural Science and Historical Studies*, University of New Hampshire, New

Hampshire Division of Parks, 1973; William M. Varrell, *Images of America. Rye and Rye Beach* (Charleston, SC: Arcadia, 1995); Federal Writers' Project, *New Hampshire*; Leavitt, *Yesterday's New Hampshire.*

26. Ralph Jimenez, "Men of Stone: The John Swenson Granite Co. Has Cut It For A Hundred Years," *Concord Monitor*, October 4, 1983; "Swenson is North America's Largest Quarrier of Granite," *New Hampshire Business Review*, May 17–30, 1991; Donna-Belle Garvin, "The Granite Quarries of Rattlesnake Hill: The Concord, New Hampshire 'Gold Mine,'" *The Journal of the Society for Industrial Archeology* 20, nos. 1–2 (1994).

27. Sanborn C. Brown and Leonard M. Rieser, *Natural Philosophy at Dartmouth: From Surveyor's Chains to the Pressure of Light* (Hanover, NH: University Press of New England, 1974); Allen L. King, "The New Photography of the Dartmouth Campus," Department of Physics and Astronomy, Dartmouth College, August 1968; "Dartmouth's Dr. Frost and the First X-Ray," *Valley News*, January 12, 1962; *Dartmouth Alumni Magazine*, 1930.

Creativity and Culture

28. Perry D. Westbrook, "Celia Thaxter's Controversy with Nature," *The New England Quarterly* 20, no. 4 (December 1947); Sharon Paiva Stephan, *One Woman's Work: The Visual Art of Celia Laighton Thaxter* (Portsmouth: Peter E. Randall, Publishers, 2001).

29. "Theodore Roosevelt, Augustus Saint-Gaudens and America's most beautiful coin," The Federal Reserve Bank of New York, 33 Liberty Street, New York; John H. Dryfhout, Curator, Saint-Gaudens NHS, "The 1907 United States Gold Coinage" (Cornish, NH: Eastern National Park & Monument Association, Saint-Gaudens National Historic Site, 1972); D. Quincy Whitney, "Honoring a sculptor's enduring legacy," *Boston Sunday Globe New Hampshire Weekly*, August 30, 1998; "Friends of the Saint-Gaudens Memorial" Newsletter, Cornish, NH (Summer 2007).

30. *The MacDowell Colony, A History of its Architecture and Development* (Peterborough, NH, 1981; reprinted August 1988); Federal Writers' Project, *New Hampshire.*

31. Betty Steele, "The League Its Forty Years," *League Newsletter*, date unknown; Federal Writers' Project, *New Hampshire.*

32. Francis G. Cleveland, *At Random*, first printed in the 1980 play programs on the occasion of the fiftieth anniversary, 1980; "The Barnstormers: Capital Campaign '97," literature brochure.

33. *The Memorial Bell Tower: A National Tribute to All American Women Who Sacrificed Their Lives in the Wars of Our Country* (Rindge, NH: Cathedral of the Pines, Publisher, 1967).

34. Jay Parini, *Robert Frost: A Life* (New York: Macmillan, 1999); *New Hampshire Individuals of Note*, Robert Lee Frost (1874–1963), http://www.johnjhenderson.com/Notables/Biographies/robert_frost.htm; Robert Frost, www.online-literature.com/frost/; Robert (Lee) Frost (1874–1963), http://www.kirjasto.sci.fi/rfrost.htm.

35. Erick Schonfeld, "Segway Creator unveils his next act," CNNMoney.com, http://money.cnn.com/2006/02/16/technology/business2_futureboy0216/index.htm; Steve Kemper, "If you do not want to hear about what he does, do not ask," *Smithsonian Magazine*, Smithsonian Institution (November 1994); "Pinnacle: Featuring Dean Kamen & FIRST" CNN, October 23, 1994; "First—The Competition," ABC-TV 20/20, April 1993.

Seasons: Work and Recreation

36. Q David Bowers, *History of Wolfeboro, NH, 1770–1994, Volume 1, A Chronological History of the Town and its People* (Wolfeboro, NH: Wolfeboro Historical Society, 1996); David R. Starbuck, "John Wentworth's Frontier Plantation in Wolfeboro, New Hampshire," *Historical New Hampshire* 43, no. 3 (Fall 1988); Benjamin Franklin Parker, *History of Wolfeborough* (New Hampshire) (Cambridge, MA: published by the town, Press of Caustic and Claflin, 1901).

37. John B. Allen, *From Skisport to Skiing, One Hundred Years of an American Sport, 1840–1940* (Amherst: University of Massachusetts, 1993); John B. Allen, "The Development of New Hampshire Skiing: 1870s–1940," New Hampshire Skiing, *Historical New Hampshire* 36 (Spring 1981); John B. Allen, "New Hampshire Skiing," New Hampshire Council for the Humanities, courtesy New England Ski Museum; Allen Adler, *New England & Thereabouts— A Ski Tracing* (Barton, VT: Netco Press, 1985); Leavitt, *Yesterday's New Hampshire*.

38. Judith H. Bennett, "The Ice Harvest," *Nostalgia, Nashua's Past*, Network Publications (February 1994); Alvin W. Taylor, "The Largest Ice House in the World," New Hampshire Profiles (January 1987).

39. Allen, *From Skisport to Skiing*; Allen, "The Development of New Hampshire Skiing"; Allen, "New Hampshire Skiing"; Adler, *New England & Thereabouts*; Leavitt, *Yesterday's New Hampshire*.

40. Jessica Payne, *Ski Industry Report*, Smithsonian Folklife Festival Survey; "Timeline of New Hampshire Downhill Skiing," New England Ski Museum; Adler, *New England & Thereabouts*.

41. Payne, *Ski Industry Report*; "Timeline of New Hampshire Downhill Skiing"; Adler, *New England & Thereabouts*; Allen, " New Hampshire Skiing."

42. Payne, *Ski Industry Report*; "Timeline of New Hampshire Downhill Skiing"; Adler, *New England & Thereabouts*; Allen, " New Hampshire Skiing."

43. Natalie Peterson, "Leading a Dog's Life," *Carroll County Independent*, March 4, 1998; Allen Lessels, "Touch of the Yukon Close to Home Dogsledding Gives These Families Some Husky Thrills," *Boston Sunday Globe New Hampshire Weekly*, February 14, 1993; *New Hampshire Collections: A Guide to our Cultural Heritage*, New Hampshire Historical Society (Concord: New Hampshire State Library, 1991); Leavitt, *Yesterday's New Hampshire*; F. Allen Burt, "The Story of Mount Washington" (Hanover, NH: Dartmouth Publications, 1960); Marjory Gane Harkness, *The Tamworth Narrative* (Freeport, ME: Bond Wheelwright Company, 1958).

44. Steve Daly, *Dem Little Bums: The Nashua Dodgers* (Concord, NH: Plaidswede Publishing, 2002); Scott C. Roper and Stephanie Abbot Roper, "We're Going to Give All We Have for This Grand Little Town," *Historical New Hampshire* 53 (Spring–Summer 1998); *New Hampshire Historical Society Newsletter* 36 (July–December 1998); Phil Dixon with Patrick J. Hannigan, *The Negro Baseball Leagues, a Photographic History* (Mattituck, NY: Amereon House, 1992).

Forests and Mountains

45. D. Quincy Whitney, "Family Tend State's Best Known Face," *Boston Globe New Hampshire Weekly*, July 12, 1992.

46. Alexander McKenzie, *World Wind Record: Measuring Gusts of 231 Miles An Hour*, World Wind Record, 1984; Salvatore Pagliuca, D.W. Mann and Charles F. Marvin, "The Great Wind of April 11–12, 1934, on Mount Washington, N.H., and its Measurement," *Monthly Weather Review* 62 (June 1934); Mount Washington Observatory press release, North Conway, NH, March 3, 1998.

47. Lucy, Wife of Ethan Allen Crawford, Esq., *History of the White Mountains* (Boston: Appalachian Mountain Club, 1979 edition of original 1845 book); Paul T. Doherty, "Pathway of the Giant: The History of the Crawford Path," *Appalachia* (December 15, 1969); Leavitt, *Yesterday's New Hampshire*; Federal Writers' Project, *New Hampshire*.

48. Peter Randall, *Mt. Washington: A Guide and Short History*, third edition (Woodstock, VT: Countryman Press, 1992); Donald H. Bray, "How the Mount Washington Railway was Built," *They Said It Couldn't Be Done: The Mount Washington Cog Railway and Its History* (Dubuque, IA: Kendall Hunt Publishing Company, 1984); Federal Writers' Project, *New Hampshire*.

49. Marny Ashburne, Madeleine Eno and Katherine Wroth, "Earnest Seekers," *AMC Outdoors* (January–February 2001); Guy and Laura Waterman, "Blazing Trails," *AMC Outdoors* (November 1994); Chris Stewart and Mike Torrey, ed., *A Century of Hospitality in High Places: The Appalachian Mountain Club Hut System 1888–1998* (Littleton, NH: Appalachian Mountain Club, 1998).

50. Burt, "The Story of Mount Washington"; Frank H. Burt, "Among the Clouds," *Appalachia* 4, no. 12 (December 1938); John D. Bardwell and Ronald P. Bergeron, *The White Mountains of New Hampshire: A Visual History* (Norfolk, Virginia Beach, VA: The Donning Company, 1989).

51. Sam H. Edes, "The Corbin Story Origin of the Great Park—The Corbin Family—Fatal Accident," *Tales From the History of Newport, NH* (Newport, NH: Argus Champion, Publishers, 1963); Sharon H. Christie, "A Look Back at the Corbin Family of Newport, NH," *Annual Town Report* (Newport, NH, 1993); interview with Sharon Christie, Newport Historical Society, November 1998.

52. David Dobbs and Richard Ober, *The Northern Forest* (White River Junction, VT: Chelsea Green Publishing Company, 1995); M.O. Schur, "Notes on Brown Company's Technological Development," Brown Company Research and Development, 1930; John J. Beer, historian of science and technology, Smithsonian Institution correspondence, July 5, 1962.

53. Rosemary Conroy, "Conservation Profile: The Other Two Leaders of the Society, Philip W. Ayres and Lawrance W. Rathbun," *Forest Notes*, SPNHF (Summer 1996); Paul Bruns, *A New Hampshire Everlasting and Unfallen* (Concord, NH: SPNHF, 1969); Evan Hill, *A Greener Earth* (Concord, NH: SPNHF, 1976).

54. *Among the Clouds*, September 1, 1899; Mrs. Freelan O. (Flora) Stanley, "The First Motor Carriage Ascent of Mt. Washington, August 31, 1899," http://bruceatkinson.com/stanley/climbtotheclouds-stanleysteamer.html.

55. *Third Report of the Meriden Bird Club* (Boston: Poole Printing Company, 1916); Joan E. Bishop, "The Meriden Bird Club," in *Choice White Pines and Good Land, A History of Plainfield and Meriden*, written by the Townspeople, edited by Philip Zea and Nancy Norwalk (Portsmouth, NH: Peter E. Randall, Publisher, 1991); Tom McCarthy, "Birds, Beasts," *New Hampshire Profiles* (September 1974); Linda Betts Burdick, ed., *New Hampshire Collections: A Guide to Our Cultural Heritage* (Concord: New Hampshire Historical Society and the New Hampshire State Library Department of Cultural Affairs, 1992).

Sea, Lake, Sky

56. *Cradle of American Shipbuilding* (Portsmouth, NH: Portsmouth Naval Shipyard, 1978); Leavitt, *Yesterday's New Hampshire*.

57. Richard E. Winslow III, *The Piscataqua Gundalow: Workhorse for a Tidal Basin Empire*, Portsmouth Marine Society, Publication Three; Thomas W. Klewin, "Gundalows on the Piscataqua," *New Hampshire Profiles* (June 1973); "The Piscataqua Gundalow Project," The National Endowment for the Humanities, Project Brochure (March 1985).

58. *Cradle of American Shipbuilding; History of the Portsmouth Naval Shipyard, Portsmouth, New Hampshire, 1800–1958, From Sails to Atoms* (Portsmouth, NH: Portsmouth Naval Shipyard, 1959).

59. "Harvard-Yale Centennial Race: Center Harbor, NH, August 3, 1952," published by the Harvard-Yale Centennial Crew Race Committee, Inc., 1952.

60. Oscar Laighton, *Ninety Years at the Isles of Shoals* (1971 reprint of the Beacon Press 1930 edition); Robert H. Whitaker, *Land of Lost Content, the Piscataqua River Basin and the Isles of Shoals* (Dover, NH: Alan Sutton Publishers, Inc., 1993); Winfield M. Thompson and Thomas W. Lawson, *The Lawson History of the America's Cup: A Record of Fifty Years* (Boston: published by Thomas W. Lawson, 1902); Varrell, *Rye and Rye Beach*.

61. Richard E. Winslow, III, *Portsmouth-Built submarines of the Portsmouth Naval Shipyard*, Publication Six (Portsmouth, NH: Portsmouth Marine Society, Peter Randall, Publisher, 1985); *Cradle of American Shipbuilding*.

62. John Noble Wilford, *We Reach the Moon* (New York: W.W. Norton & Co., Inc., 1969); M. Scott Carpenter, L. Gordon Cooper Jr., John H. Glenn Jr., Virgil I. Grissom, Walter M. Schirra Jr., Alan B. Shepard Jr. and Donald K. Slayton, *We Seven* (New York: Simon & Schuster, Inc., 1962).

63. Grace George Corrigan, *A Journal for Christa, Christa McAuliffe, Teacher in Space* (Lincoln: University of Nebraska Press, 1993); Robert T. Hohler, *"I Touch the Future"…the Story of Christa McAuliffe* (New York: Random House, 1986).

ABOUT THE AUTHOR

D.Quincy Whitney was the primary arts feature writer for the *Boston Globe New Hampshire Weekly* for fourteen years, newsletter editor for the League of New Hampshire Craftsmen and the American Textile History Museum and a college textbook sales representative for D.C. Heath, Random House and Harper & Row. Whitney is a Eugene O'Neill Critic Fellow (1989) and a Salzburg Seminar Fellow for "The Modern Novel" (1998) and "Biography as a Mirror on Society" (2006). From 2004 to 2006, Whitney was a research fellow at the Metropolitan Museum of Art in New York City, where she completed her research for the biography of internationally renowned American female violin maker Carleen Hutchins. Whitney is a graduate of Wake Forest University.

For more information go to www.quincywhitney.com.

CPSIA information can be obtained
at www.ICGtesting.com
Printed in the USA
LVHW020023050820
662302LV00016B/818

9 781540 219145